First published, 2012, by

columba press

55A Spruce Avenue, Stillorgan Industrial Park,
Blackrock, Co Dublin
www.columba.ie

ISBN 978-1-85607-751-4

Design and layout by Emer O Boyle
Printed by Nicholson and Bass

Sister Maureen's Selection of
IRISH ART
with reflections

MAUREEN MacMAHON

Sister Maureen's Selection of

IRISH ART

with reflections

the columba press

Contents

Foreword by Maureen MacMahon OP
Introduction by Michael Judge

Acknowledgements

Foreword

This book is the culmination of my many years as a contributor to the Sacred Heart Messenger Magazine, writing on various aspects of Art. One day back in 1997, Anne Duff, a member, then, of the staff of Messenger Publications, proposed that I write a series of articles on specific paintings, ending with a spiritual reflection or comment. After some hesitation I undertook the task, confining myself to the work of Irish artists. Thirteen years later it seemed a good idea to combine some of the articles into a book or books. The first book (2009), published by Messenger Publications, was well accepted, this encouraged me to put together another little volume.

It is important to state that the reflections are purely personal, sparked off by either the beauty of the painting, its subject matter or by a personal experience of the artist. They are not meant to be an interpretation of the painting or sculpture, nor do I claim to have an insight into the artist's mind. As a practising painter I am fully aware that preconceived ideas, especially lofty ones, are soon changed or modified by the physical application of paint or the mood of the moment. Many factors go into the shaping of a painting or a piece of sculpture.

In choosing artists from the past and the present I have encompassed almost two hundred years of Irish art history. Male and female artists are represented, painters and sculptors. Consequently there is a variety of styles, some traditionally academic, some more "modern" for the era covered. You will discover familiar names and other names seldom seen or heard of, but all of these talented men and women have contributed or still contribute to the artistic heritage of our land and nation.

Maureen MacMahon OP

Introduction

"He who can, does: he who can't teaches"
When he first conceived it, Shaw must have known immediately how shallow this spurious aphorism was, so he hid it in the fiction of Man and Superman as one of the Maxims for Revolutionists which might be disowned if such action were required. It certainly is not true. Maureen MacMahon OP is living proof of this; she is both a superb doer and an inspirational teacher. She is many other things, of course, as this book testifies, but doing and teaching are enough for now.

I first met Maureen when my daughters went to Sion Hill School and came home with the news that their art teacher had the delightfully foreign name of Grignion. They loved her and they loved her classes, and soon they discovering artistic talent in themselves that they hadn't known was there.

Many years later in The High Loft Studio, Sr Maureen, who had by then resumed her original name, conducted art classes for adults, including my wife. She was as much at home with grownups as she had been with children, identifying and cultivating vast areas of ability unrealised until her deft hands and encouraging words brought them into flower.

As with all institutions devoted to artistic activity, the history of The High Loft was one of constant struggle against various enemies. Planning regulations, financial restraints and natural disasters raised difficulties and built barriers, but Maureen, the doughty doer, fought them all the way and overcame them in the end.

It is the measure of this ferocious doer/teacher that even now she continues to teach with as much vigour as ever.

Yet she has still found time and energy to produce this beautiful book. The second of its kind, it contains treasures on every page, in every picture and in every well-chosen word.

You know the format by now. Maureen selects a number of artists and their creations and places them before us for our consideration. She gives us some significant information about the artist and takes us on a guided tour of the painting or sculpture as she sees it. She never preaches or bullies us, never suggests that there is only one way to respond to artistic excellence, but prompts us to see for ourselves and make the work of art our own by absorbing it into our sensibilities and storing it away in our hearts.

Then this remarkable woman allows us into her own heart and reveals the spiritual strength she derives from the contemplation of these beautiful things made by human hands for whatever reason, but all drawing us towards the same inevitable conclusion that beauty is truth and truth is beauty.

"This is all ye need to know."

Michael Judge

LITTLE HARBOUR, DUN LAOGHAIRE
by Kathleen Bridle RUA
(1857-1989)

The first thing that strikes me about this painting is its liveliness and freshness. It is achieved by the bold blobs of paint applied with short brush strokes, wet into wet, and the bobbing boats with the vertical thrust of their masts lurching in all directions against the horizontal lines of the hills. The contrast of complementary colours contributes to the lively effect.

The painter, Kathleen Bridle, daughter of an Irish coastguard officer, was born in Kent, England, in 1897, trained in Dublin and lived for most of her long life in Enniskillen in Northern Ireland. She chose to come to Dublin in her late teens to attend the Metropolitan School of Art there.

Kathleen made great strides in oil painting under Sean Keating. Her drawing tutor was James (Jimmy) Golden, and George Atkinson introduced her to watercolour painting. She was in her element, having never wanted to do anything else but draw and paint and so her memories of Dublin were happy ones. It was here that she revelled in the freedom to develop her talents. She won two silver medals and a scholarship, which enabled her to pursue her studies in London at the Royal College of Art. In the city, she temporarily shared accommodation with Norah McGuinness. Money was always a problem but a further scholarship gave her another year of study.

She returned to Dublin to join the stained glass studios of Harry Clarke. Her stay there was brief, because she found the art of stained glass too confining for her liking.

A former teacher and friend, John Hunter, encouraged her to apply for the post of art teacher at the Enniskillen Technical School in Co Fermanagh. She got the job and travelled to the town one wet wintry night in January 1926. Her first impressions were disastrous. "I thought it was a dreadful place", she told TP Flanagan in an interview many years later. However she worked hard, teaching part time in as many as five different schools until she found full time employment in the Collegiate School in Enniskillen at the age of 58! As her reputation as a teacher grew she shaped the careers of many young aspiring artists, two of whom became important painters – William Scott and Terence P. Flanagan. She took her teaching seriously and never appeared tired or bored by her students. In her hands watercolour became an exciting medium. Somehow she managed time for her own painting, exhibited widely and travelled extensively. She was elected a full member of the RUA Academy in 1948 and continued to paint into her nineties. Her final years were lonely, following the death of her sister, who had come to live with her. She died in 1989.

All her life Kathleen shared her love of painting unselfishly with others and in this sharing she found happiness and fulfilment. Saint Paul exhorts us to show our love by being helpful to one another.

Who gives much receives much, for we possess that which we give

Watercolour 35 x 51cm
Private Collection

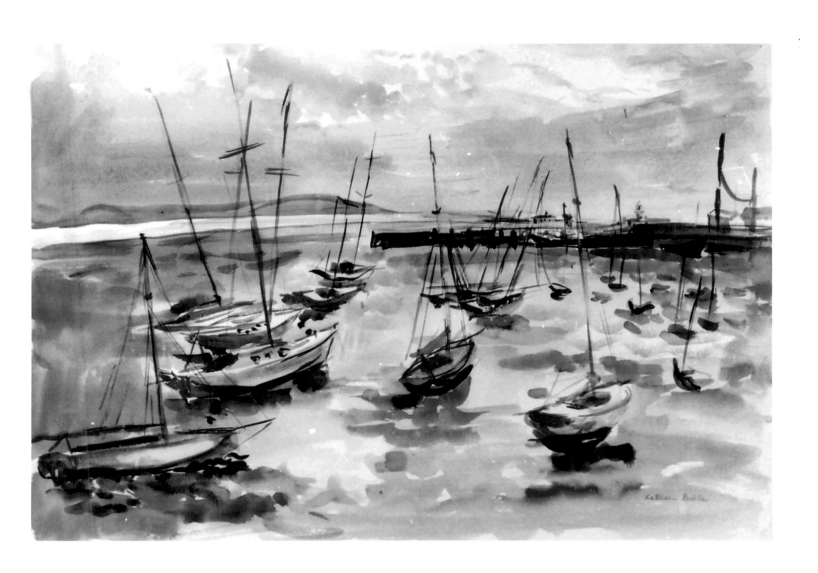

Kathleen Budd

HOOKER OFF CORK HARBOUR
by Richard Brydges-Beechy HRHA
(1808-1895)

The black clouds of the Atlantic storm are rolling away, allowing a glimmer of light to open up in the dark sky. The little hooker, with its distinctive red-brown sails, is heading into the wind in the turbulent sea, not far from land. The larger two-masted vessel appears to be heeling over in the strong gale, striving to reach the harbour. Further away in the cold green-blue water is another sailing ship, struggling to keep upright. Watery sunlight picks out shadowy landmarks of East Cork and the lighthouse at Roche's Point.

In this dramatic painting the gifted Cork-born marine artist, Richard Brydges Beechey, sets the light ochre coloured sails against the black storm-filled clouds. A shaft of light catches the red sails of the hooker, the prow of the larger vessel and the tips of the choppy waves. The drama of light against dark, dark against light helps to create the mood of the moment, while the design of the billowing sails and the pattern of the waves with their foaming tops all set up subtle diagonal rhythms across the canvas. The men and women in the hooker are visibly battling hard to keep the boat on course. Yet there is about them a relaxed confidence. From long experience they have learned how to master the sea whatever the weather.

Richard was a master sailor himself. He joined the Royal Navy at the age of fourteen, and spent several years at sea. On his return home, he married the eldest daughter of Robert Smyth of Portlick Castle, Co. Westmeath. Setting sail once again, he served under his famous brother, Captain Frederick William Beechey and eventually rose through the ranks to become an admiral. While at sea, he kept up his interest in art and painted many canvases, some of which he submitted to the Royal Academy in London. Later he exhibited a number of oil paintings of marine scenes at the RHA in Dublin and was made an honorary member of that Academy in 1868. He inherited his artistic gift from his parents, both of whom were painters and made an equal success of a naval career and that of an artist. He loved to paint the sea in all its moods, but especially when it was whipped up with the fury of a gale force wind.

What power God has given us, men and women, to harness and control the sea, the sky, the land and all they contain. In the words of the psalmist:

With glory and honour you crowned him,
Gave him power over the works of your hand,
Put all things under his feet. (Psalm 8)

Oil on canvas 79 x 112cm
The Gorry Gallery

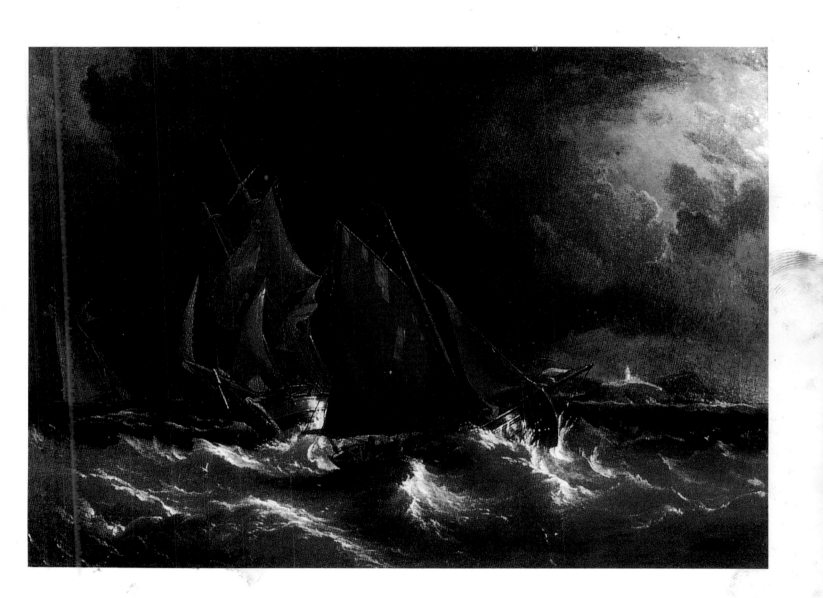

CLADDAGH DUFF, CONNEMARA
by George Campbell RHA
(1917-1979)

The grey stone church dominates the barren landscape of this corner of Connemara in Co. Galway. Mass is over, the people have wound their way home on the zigzag boreen that slopes away down the hill between the patchwork fields, strewn with stones, two women have stopped to chat on their way home. George Campbell paints a bleak picture, but not a cold one. There are subtle tones of ochre and warm grey throughout the composition. A wild beauty prevails.

The artist was one of three brothers, all painters. Their mother, a remarkable woman, took up painting in her seventies and continued until her ninety-first birthday! She painted under the name of Gretta Bowen. George was born in Arklow, Co. Wicklow in 1917. When he was four years old the family moved to Belfast, where his father, Matthew Campbell, opened a catering business. Four years later Matthew was dead. Gretta took in boarders to support herself and her three sons. George was sent to the Masonic Orphan Boys' School in Clonskeagh, Dublin, where he was a boarder for six years. On leaving school he returned to Belfast and worked in various jobs but got no satisfaction from them. On the outbreak of Second World War in 1939 George felt the futility of going to work, when everything around him was being destroyed. One day he found some brushes and paint lying around. It was the beginning of a painting career and he never looked back. Art became his life. Art College was not an option for him, so he was virtually self-taught. He said that his great pleasure was in the doing, not the finished product. At times he was near starvation. Belfast was a blitzed city, where no one was interested in the handful of artists struggling to make a living there.

At the end of the war in 1945, George went, with his wife Madge, to London for six months. On his return he paid a visit to Victor Waddington in Dublin. This great friend of so many young aspiring artists recognised his worth and organised a one-man show for him. It was a sell out, and just the encouragement he needed. Around about this time he went to stay, for one month, with his friend Gerard Dillon, on Innislacken Island, off the Connemara coast. Here they spent their time sketching and painting. He probably painted "Claddagh Duff" during this period.

On his first visit to Spain in the winter of 1951, he fell in love with its people, its way of life and its music. Returning there again and again he became a fluent Spanish speaker, mastered the Spanish guitar and was accepted as a player of flamenco. From then on, Spain as well as Ireland, was where he found his inspiration, from cottages to rocks, from reeds to ruins, from picadors to gypsies. All found their way into his paintings. He first exhibited at the RHA in Dublin in 1947 and became a regular contributor for almost 30 years. He died in May, 1979 in Dublin, but is buried in Laragh, Co Wicklow.

In this complex painting of subtle tones and stark shapes the church stands out as a symbol of strength and stability, a beacon of light and a place of refuge for the broken and the burdened, a place where the burning love of God for us, is ever present.

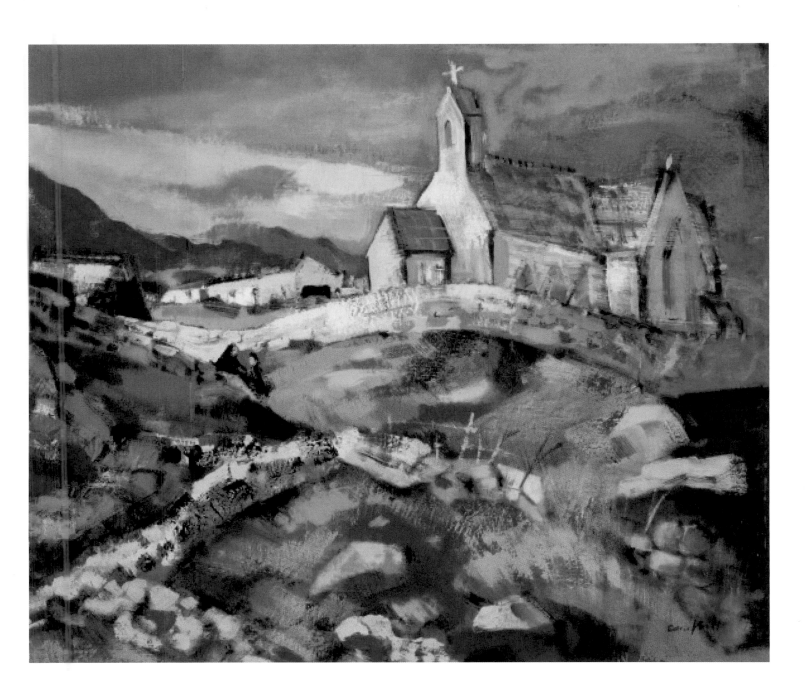

SONG OF THE MAD PRINCE

by Harry Clarke RHA

(1889-1931)

This panel is by one of our most celebrated stained glass artists, Harry Clarke. His father, Joshua Clarke who was from Leeds in England and Bridget MacGonigal from Sligo in Ireland, set up a church decoration and stained glass business in Dublin in 1886.

Harry and his brother, Walter, received their education at the Marlborough Street Model Schools and Belvedere College in Dublin. At the age of fourteen Harry was apprenticed to his father's business. He quickly learned the basic techniques of producing stained glass under William Nagle, a gifted draughtsman and designer, and received a scholarship to attend the Dublin Metropolitan School of Art. While there, he was awarded many prizes and a further scholarship to travel. On a visit to Paris he was amazed at and influenced by the richly coloured windows of Chartres Cathedral.

Back in Ireland his unique style and workmanship won him a commission to design a set of eleven windows, depicting Irish saints, for the Honan chapel in University College, Cork. Other commissions followed from Ireland, England, Scotland, Wales, Australia and the United States of America.

He worked tirelessly in spite of constant ill health. At the death of his father in 1921 he and his brother took over the business as well as the studios. Gradually the pressure of work, the toxic chemicals he used and an inherited tendency to tuberculosis cut short his life. He contracted the dreaded disease so prevalent then in his native land. In an attempt to stem its advance he stayed for many months in a Swiss sanatorium, but to no avail. He died, in his sleep, at Coire, a small Swiss village, on his way back to Dublin on the night of 6 January 1934, at the age of forty-two. He left behind an unrivalled legacy of artistic output. In his designs for stained glass windows and panels as well as for book illustrations he used a unique blend of stylised images and intricate designs, based on religious and literary themes in rich, glowing colours with imaginative, delicate decoration.

This small panel, the *Song of the Mad Prince,* now in the National Gallery, was commissioned by Thomas Bodkin, when he was Director of the Gallery and a close friend of the artist. It was inspired by the poem of the same name by Walter de la Mare. The brilliant colours and the intricate painted patterns are handled with superb craftsmanship, resulting in a masterly technical and artistic achievement. The prince stands above the flower-strewn grave of his loved one, with a sad melancholy expression and a gesture of hopelessness. The figures in the background represent his father, the king, set against a moonlit castle and the queen surrounded by a circle of ruby light, an exquisite, haunting, image.

Mad is not a word in use today, but whatever the change in language mental illness is still with us. Those suffering from it need love and understanding, a love that will make them feel wanted. A young man from the L'Arche Community, who was guilty of many misdemeanours, heard the words, "I stand at the door and knock" (Rev 3:20). When asked what he thought Jesus would say to him when he opened the door, he replied: "He will take me in his arms and say, you are my beloved son"!

God loves us all.

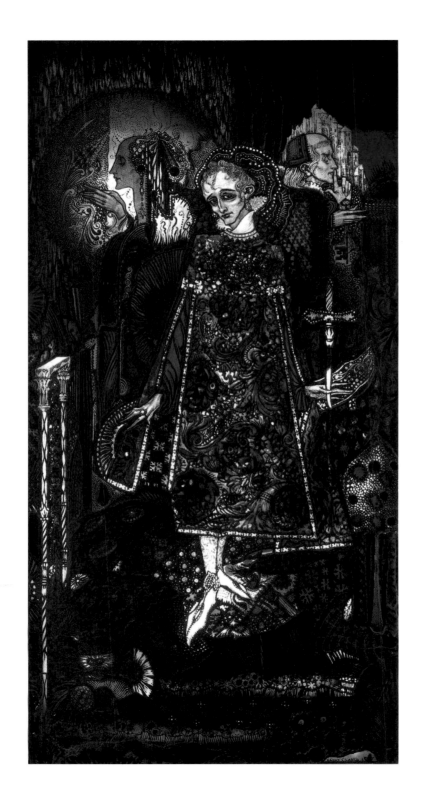

GOING TO MASS
by James Humbert Craig RHA
(1877-1944)

It is a bleak, blustery, grey day in Connemara in the west of Ireland, and yet the people, young and old, set out on the country road to go to Mass. They come from far and near, from the little scattered homes, to worship God. It seems to me that, to them, it is more than an obligation, more than a ritual. It is at the heart of their faith as it has been for hundreds of years. James Humbert Craig, son of a wholesale merchant from Belfast and a Swiss mother, was born on 12 July 1877. There was a long tradition of art in his mother's family and she encouraged her little son's efforts with pencil and pen as well as helping him to experiment with brushes and paints. When old enough he tried working in his father's business, but it held no satisfaction for him. He bowed to the inevitable and pursued a career in art. For a short period he attended the Belfast College of Art, but other than that he was virtually self taught. From a cottage in Cushendun, Co Antrim , where he set up a studio, he wandered through the Glens of Antrim, seeking subjects for painting. Sometimes he went further afield to the hills and coast of Donegal or to the wild beauty of Connemara in the west. He observed nature closely. With an artist's eye, skill and sensitivity he sought to interpret nature rather than to copy it. His work has been compared with that of Paul Henry and, like Henry, he won success as a painter. Occasionally he took his painting paraphernalia across the water to paint in foreign lands – Switzerland, France or Spain. He exhibited at the RHA in Dublin for many years, becoming an associate member and finally a full member in 1928. He was also elected to the Ulster Academy of Arts. At his death in 1944 he was laid to rest in Cushendall in Co Antrim. In *Going to Mass,* he painted the people as if they were one with the landscape, using the same loose brushstrokes as those he employed to suggest the foaming sea, the glimmer of light breaking through the threatening clouds, and the little, hard-won cultivated plots within the boundaries of dry stone walls.

When we go to Mass, whether to small church or great cathedral, we come together to take part in a living experience. The Mass is our response to the limitless giving of God to us. We respond, not as spectators but as participants, with love, worship, thanksgiving and surrender. It is a mystery, beyond the grasp of human thinking. Faith alone gives meaning to it.

"Jesus took the bread, broke it and said;
Take and eat, this is my body"
(Matt 26:26)

Oil on canvas 37.7 x 50.5cm
Crawford Gallery,

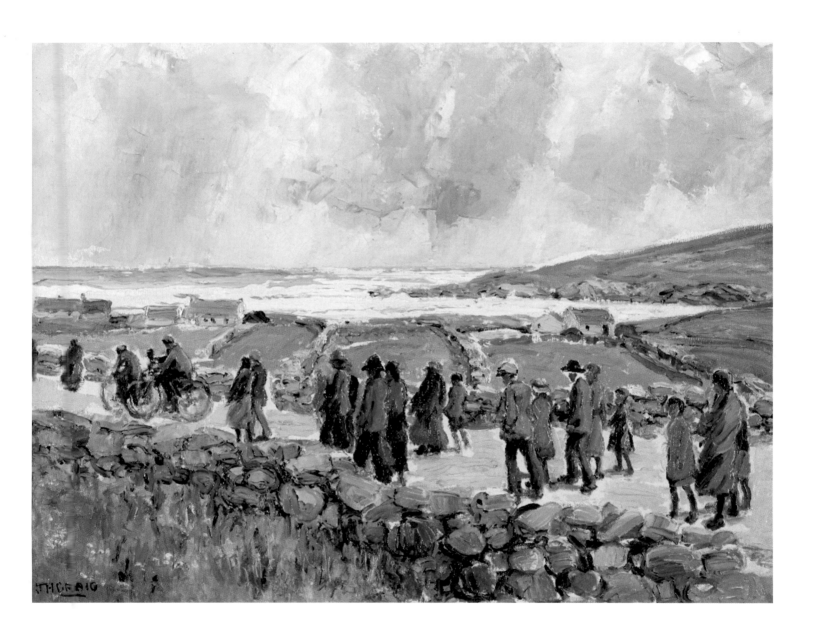

THE GARDEN
by William Crozier HRHA
(1930-2011)

It is entitled *The Garden*. All the elements of a garden are here ... a strip of sky, trees, shrubs, dark earth and splashes of colour. The parts are not arranged as we might expect them to be but as the artist saw them in his mind's eye, suggesting a beautiful garden. It is a good example of this phase of William Crozier's work.

An Irish citizen, in Ireland since 1983, living in Kilkoe near Skibereen Co Cork, he was born in Scotland of Irish parents in 1930. When asked to define his nationality, he said he had little enthusiasm for particulars of identity. "I need to be myself and myself alone." When speaking about his parents, who had left Ballinderry, Co Antrim in Northern Ireland to live in Glasgow, Scotland, he said, "My parents were more Scottish than Irish, when they were not being more Irish than Scottish." William's love for the arts was inherited in part from his father, his love of music from his mother, and his love of liberty from both. On the day he graduated from the Glasgow School of Art, he headed off to Paris for nine months. The paintings of Hartung and Soulage excited him, as did the exhibitions of Matisse's cutouts and Picasso's war paintings.

From Paris he travelled to Dublin and worked there as a set designer for the Olympia and the Theatre Royal. Within four years he was in London, continuing his theatre work but supplementing his income by teaching in different colleges throughout England. An invitation from his friend, Anthony Cronin the poet, to share a house with him in Malaga in Spain, suited Crozier's restless spirit and he willingly accepted. All the time he was producing paintings for exhibitions in several European galleries, confirming his status as a truly European painter. Over the years his paintings have gone through many phases, from the tortuous vine paintings of Malaga to figurative compositions using skeletons. These latter were sparked off by a visit to Belsen, and occupied his mind for years afterwards.

It would seem that his sojourns to the south of Ireland and his subsequent residence there turned his attention more and more to the landscape. He rarely made sketches. Ideas formed in his mind, for long or short periods, and resulted in a painting session of intense concentration. He admitted, "Painting is an act of self-murder in which a sense of achievement is rare and defeat a daily occurrence". Already an honorary member of the RHA, he was elected to Aosdana in 1992. He died on 12 July 2011, survived by his second wife, Katharine, a son and a daughter.

The word *garden* conjures up an image of a secluded and safe place, a beautiful place, full of growing things, whether cultivated or wild. In order to retain its beauty it needs to be cared for, to be given special attention. In the same way we have to care for the garden of our souls, by works of charity and by prayer.

If you bestow your bread on the hungry and satisfy the afflicted, then the Lord will guide you always. He will renew your strength and you shall be like a watered garden, like a spring whose water never fails.
(Is 58:11)

Oil on canvas 78 x 84cm
Collection: Kelly's Hotel, Rosslare

STILL LIFE WITH TULIPS
by May Guinness
(1863-1955)

We are here considering another of those enthusiastic, forward looking and courageous women artists who had a profound influence in breaking with conservatism and launching Irish art into the modern era. She was born at Tibradden in Rathfarnham, then a suburb of Dublin, in 1863. The family was wealthy and landed. May was educated privately by governesses and at Miss Power's School. From an early age she drew portraits of her friends and loved to play the piano. The second eldest of seven children, her academic education was cut short by an obligation to care for her siblings, two of whom had died from tuberculosis. The death of these young sisters had a profound effect on May. In her determination not to succumb to the scourge of TB she subsequently spent the winters in France. Her art studies, had to be deferred until she was in her thirties. In the meantime, however, she painted and exhibited at the RHA.

Her first trip abroad in 1894, with Mildred A. Butler, was to Newlyn in Cornwall to study under Norman Garstin. She was certainly in France in 1910, perhaps earlier, painting fairs, weddings and processions. In 1914 she interrupted her studies to join the French army as a military nurse. A brave, independent woman she was rewarded the Croix de Guerre at the end of the war. Painting now became her life's work. In Paris she studied under Van Dongan, Andre Lhote and the Spaniard, Aglada. It is possible to find influences of these artists in her work at different times. Sometimes, as she said, she wielded her brush with "flat rhythmic arrangements of line and colour", at other times with more vigorous splashes of colour. Though she exposed herself to a wide range of influences she finally developed a personal style that included both traditional and modern trends. A vigorous campaigner for the saving of the Hugh Lane pictures for Dublin, she was one of the twenty-one signatories calling for a public meeting to discuss the problem.

In this Still Life with Tulips there is an exuberance of brushwork, both strong and delicate. The wayward tulips are alive and scatter in all directions. They reach out to the edges of the canvas, filling the whole space, thus forming a circular composition. In repeating the crimsons, blues and greens of the main motif of flowers and vase in the shapes around them the artist has created a unity, which is arresting and very pleasing.

As well as painting herself, she collected the paintings of others. On her walls in Rathfarnham could be found works by Picasso, Matisse, Bonnard, Dufy and others. A cultured lady with a strong personality and a gift for entertaining others, she died in 1955 at the age of 92. God's mysterious creativity is being continuously made manifest in this evolving universe. The variety in shape, size, form, smell, colour and sheer beauty of flowers must make us stop and wonder.

"The creatures you made to let your life show;
The flowers and trees that help us to know
The heart of Love" (Canticle of the Sun)

Oil on canvas 62.5 x 76 cm
Private collection

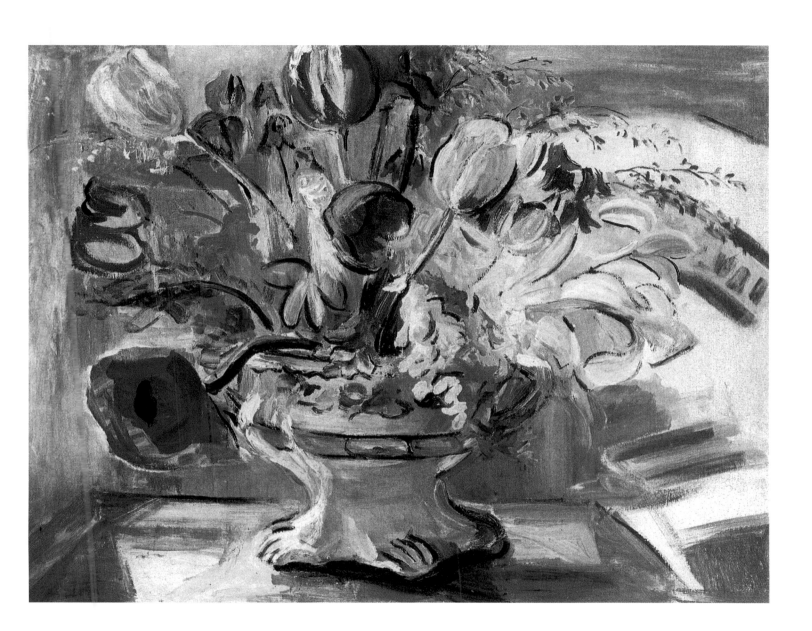

SNOW IN COUNTY DOWN

by Letitia Hamilton RHA
(1878-1964)

The sky darkens, the air takes on a brooding stillness. The first flakes of snow whirl to the ground. The cold, white storm gathers momentum, covering everything in nature's whitewash. Familiar shapes are changed. The ugly and the sordid are covered up. We are left standing in wonder and awe, holding our breath at the unsullied beauty, not daring to mark the smooth, silvery surface. Letitia Hamilton has captured this beauty in her painting of the snow in Co Down. She was born into an artistic family in Dunboyne, Co Meath, in 1878. After her secondary education in Alexandra College Dublin, she studied art at the Metropolitan School of Art under Sir William Orpen. She continued her studies at the Slade School of Fine Art in London and then in Belgium. Further travels brought her to France, Italy and Yugoslavia. Through the many influences she encountered, she developed a style that was bold and vigorous. In Ireland her favourite subjects were country fairs, markets and above all hunting scenes, but in her continental travels, she took great delight in painting the areas around the northern lakes of Italy. Visits to Venice between 1920 and 1930 resulted in a palette of richer, original colours, experiments with the effects of light and more confident brushwork. From this time she often made use of the palette knife to achieve an impasto effect. She employs it here very effectively to suggest the weight of snow on the bushes and trees. A subtle blend of cool blues, pink and yellow shows up the reflective nature of snow. Only a minimum of pure white paint is used.

Together with other women painters of her day, Letitia was at the forefront of the new artistic movement that was taking place in Dublin in the early years of the 20th century. She was one of the founder members of the Dublin Painters' Society. In 1902 she became an active member of the Watercolour Society of Ireland and was a regular exhibitor. She also submitted paintings, every year, to the Royal Hibernian Academy, and was elected a full member of the Academy in 1944. Over the years at least 200 works of hers were shown, the last one just before her death in 1964.

The dreamland that snow creates is quickly shattered. Compacted snowflakes fall from bush and tree, from rooftops and windowsills and are trampled into slush by countless feet. The cover-up is over!

Living in the real world we have to face the ugly and the sordid, as well as the beautiful and the good. Do you not sometimes wish that the ugly things in life could be covered up permanently? But life is not like that. Poverty, sickness, cruelty and death are part of our existence here. Why it is so, I do not know, but I believe that God sent his Son to live among us to show us how to cope with things as they are. He alleviated suffering when he came in contact with it. When the leper cried out to him, *Lord if you will you can make me clean*, he answered, *I will,* and the leper was healed. But he did not cure everyone. Neither can we heal or care for everyone, but we can help those closest to us.

Oil on canvas 50.5 x 60cm
Collection: Dublin City Gallery, The Hugh Lane

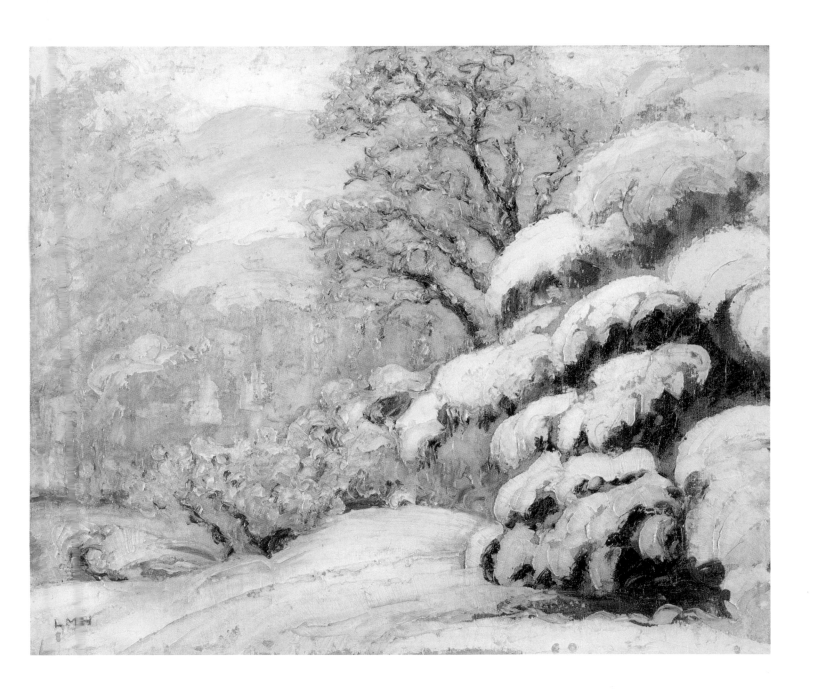

SUNLIT ROOFS
by Ernest Hayes RHA
(1914-1978)

In this painting the ordinary has been transformed into something extraordinary. The whitewashed walls of the old house on a farm in Co Wicklow glow with subtle, reflective colours. The slanting sun has cast strong shadows from the irregular chimneys on to the roof tops and the slates have become jewels of coloured light. It is a picture of light and dark, sunshine and shadow. It is what the artist saw when he looked at this unpromising corner of the neglected farmyard.

Born in 1914, Ernest Hayes came from a middle-class Dublin family. His father, an ophthalmic optician, encouraged his artistic son to pursue a career in art. While still at secondary school in Terenure College, Ernest attended the Metropolitan School of Art. He became a full-time student there, in 1931 under Sean Keating. However it was Dermod O'Brien, President of the Royal Hibernian Academy, who had the greatest influence on his art and who became his friend.

He tasted early success and recognition. He exhibited regularly at the RHA and was elected a full member of the Academy in 1945. He was also President of the Dublin Sketching Club for ten years. A little later in his career he was to experience the reverse of good fortune when he set up a studio at 64 Dawson Street in Dublin. Portrait commissions, which at first were numerous, dwindled to a few. Personal problems contributed to this decline, not least of which was the fatal illness and death of his wife, after only a few years of marriage. He was forced to close the studio. That was in 1969. The following year, while based in London, he met Hildegard Van Hobe, a beautiful German Lady, who became his second wife. This proved to be a very happy time for the artist, a period of great creative activity. He concentrated on landscapes and dramatic seascapes, with occasional portraits of family and friends.

Sunlit Roofs was painted during this productive time. He was always interested in the play of light on hard surfaces, on walls and roofs, on laneways and trees. His later paintings are bathed in light and colour. As he travelled through Germany, Holland, Denmark, Italy and France he must have become aware of the revolution in art that was then taking place in Europe. However, the shock waves still rippling in the wake of the Fauves, the Cubists, the Dadaists and others washed over his head. Though leaning towards Impressionism, he remained a traditionalist, alone and aloof from contemporary movements. Shortly before he died in 1978, he declared, echoing the words of Renoir, *"I am learning; I am beginning to paint."* He painted to the end, leaving behind a legacy (mainly in private collections) of nostalgic, poetic paintings.

It is not easy to turn the shadows of life into poetry. When the sun shines and things go well, it is easy to praise and thank God, but when the shadows fall, it is hard to see beyond the dark dismal days. It is then that trust in God is all that is left. He will not let us down, however long the shadows.

"I am in trouble, but my trust is in you, O Lord" (Ps 31: 9)

Oil on canvas 51 x 72cm
Private collection

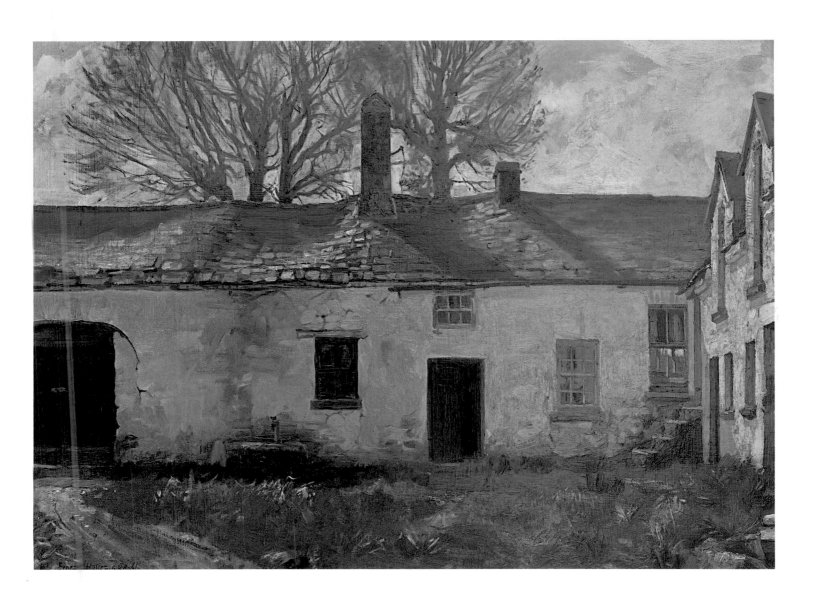

SAINT PATRICK LIGHTING THE FIRE AT SLANE
by Michael Healy
(1873-1941)

Some artists have a spotlight of fame directed on them from an early age, others have to wait longer. Then there are those who live and work almost unnoticed. Michael Healy belonged to this latter category. Yet he was a superb draughtsman and a pioneer in the technique of his chosen medium of artistic expression—stained glass.

He was born into a Dublin family of modest means, living at 40 Bishop Street, in 1873. Because of the early death of his father, he was obliged to enter the workforce at the age of fourteen. But he loved to draw and spent all his pennies on pencils. Ten years passed by before he was able to fulfil his ambition to study art. In 1897 he attended the Metropolitan School of Art and the RHA Schools, progressing quickly, with the utmost industry, through the different grades. His first job was illustrator of the *Irish Rosary* magazine, offered to him by the editor, Fr Glendon OP, who recognised his exceptional artistic talent. Fr Glendon was able to get him several other commissions but he urged Michael to continue his studies in Europe, obtaining for him an introduction to the Florentine painter, de Bacci-Venuti. Michael entered the studio of the Master as a pupil and ended up by becoming a lifelong friend.

He returned to Ireland with the intention of entering the Dominican Order but first took on the post of art teacher in Newbridge College, Co Kildare. After one year, realising that he was not called to the religious life he took a very decisive step in a different direction. He joined the new Stained Glass firm of "An Túr Gloine", founded by Sarah Purser in 1903. His first window, depicting Saint Simeon, was for Loughrea Cathedral. In the years that followed, working beside other Irish stained glass artists of the twentieth century, such as AE Child, Wilhelmina Geddes and Evie Hone, he designed and crafted hundreds of windows, not only for clients in Ireland but for those in other countries, notably France, England and the USA. Illness prevented him from finishing his final commission of seven windows representing the Seven Dolours of Mary for a chapel in Clongowes Wood College. The work was completed by his friend and colleague, Evie Hone. So it was that this quiet, gentle, solitary, gifted man slipped silently to his death and to his reward in 1941.

The Saint Patrick window for the Church of the Sacred Heart, Donnybrook, Dublin 4, is a cinquefoil panel of five arcs. In the centre, the intrepid Patrick raises his arms in triumph, the triumph of the risen Lord, symbolised by the fire he had lit on the hill of Slane at Tara, in defiance of the High King, whose prerogative it was to light the first fire. The Holy Spirit, in the form of a dove, hovers over the fearless Patrick. Two angels occupy the left and right arcs. In the lower left a warrior bows down in homage and on the right an ancient druid raises his eyes to the saint. Irish people, all over the world, have a great love and reverence for Saint Patrick. His attention to prayer, day and night, as boy-slave and later as priest and bishop, is beacon and model for us.

For my shield this day I call a mighty power, the Holy Trinity,
Affirming threeness, confessing oneness in the making of all, through love.
(*Breastplate of St Patrick*)

Ink, pencil and watercolour on paper, 27.2 x 28cm
National Gallery of Ireland Collection
Photos © National Gallery of Ireland

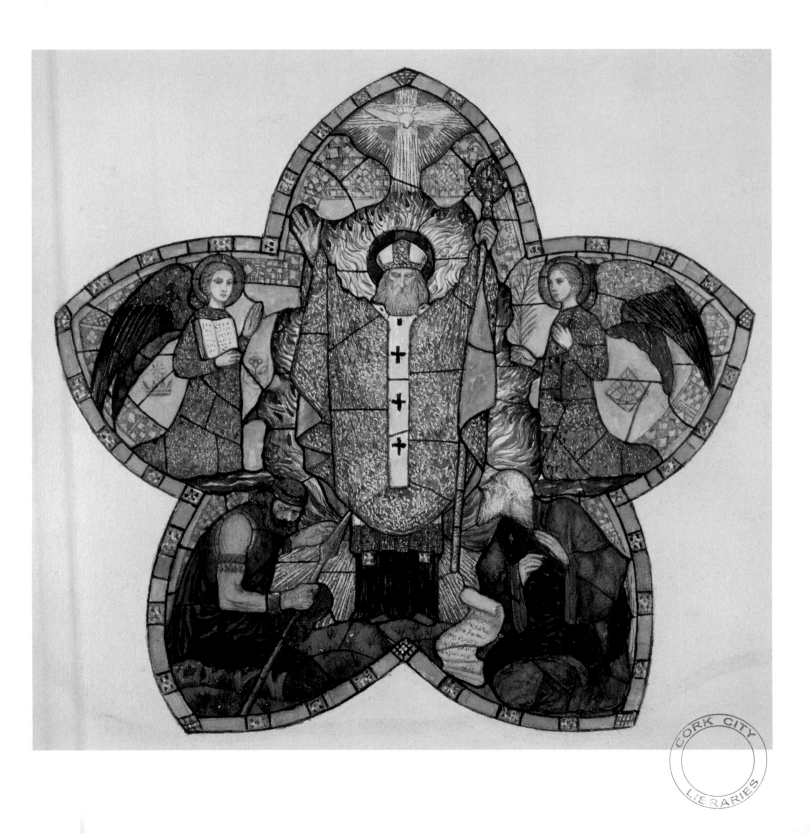

A STUDY OF FLOWERS
by Grace Henry HRHA
(1868-1953)

It was a chance meeting in Paris that brought the Scottish-born Grace Mitchell and Paul Henry together in 1900, resulting in a romance that culminated in marriage. The couple lived and painted in London for a number of years. A chance remark by a friend directed their steps to an island, called Achill, off the west coast of Ireland. Their visit there began with a short holiday of a few weeks, but turned into a nine-year stay. The spectacular vistas and the rugged beauty of the island captivated them both, but especially Paul. Grace grew tired of the remoteness of the place and the hardship of the bitter winters. With her natural vivacity she longed for more contact with other people, with whom she could converse and exchange ideas in her fun-loving and witty way.

They moved to Dublin in 1919 and involved themselves, with several other artists, in setting up the Society of Dublin Painters, as an alternative to the Academy and its diehard adherents. The following years were unhappy ones for both Grace and Paul and their marriage began to show signs of breaking. They drifted apart and went their own ways, though they continued to hold joint exhibitions. Finally they separated.

Grace travelled to France and Italy, where she produced some of her best paintings. Her work was more experimental and innovative than her husband's, but did not receive the credit it deserved in her lifetime. Her life assumed a nomadic pattern, entailing much travel. Eventually she returned to Ireland, at the outbreak of the Second World War in 1939. She continued to paint, and was amazingly versatile in her choice of subjects, and daring in her approach and style. She used strong colour contrasts, painting with fluid, feverish brushwork. At its best her work equalled and sometimes surpassed that of her more famous contemporaries. She became a regular exhibitor at the RHA and was elected as an honorary member a few years before her death in 1953. For Grace, money was always scarce. Her final years were lived out in cheap Dublin hotels, alone and often lonely, with no relatives and few friends, but she never lost her sense of humour.

The tender beauty of this portrait of flowers in a vase shows her skill as a colourist and her easy modernistic style. The sensitive design and cool colour harmony has resulted in a very pleasing study.

We all have our troubles, but let us not complain unduly. *Seal my lips on my aches and pains*, prays a seventeenth century nun. Nor should we look for trouble. *Who would choose trouble and difficulty?* asks St Augustine in his Confessions. And again: *You command us to endure them, not to love them. No one loves what he endures, though he may love to endure.*

Oil on paper 54 x 43cm
Limerick City Gallery of Art

PORTRAIT OF TWO CHILDREN
by Thomas Hickey
(1741-1824)

This is a delightful painting of two little girls, possibly nieces rather than daughters of the artist, Thomas Hickey. He was only twenty-eight years old when he painted it. Hickey was a Dubliner, born in Capel Street in May 1741. At a young age, perhaps fourteen or fifteen years, he became a student, a very industrious student, at the Dublin Society School, where he studied drawing and painting. While there he received many prizes for portraiture. At twentyone he left for Rome and became one of a circle of artists in that city. Three years later he went to Naples, stayed there for a few years and returned to Dublin via Capua. In a subsequent sojourn in Spain he put more enthusiasm into absorbing its culture and learning its language, than in producing paintings. He wrote, "... remaining for nearly six years, I became versed in the literature and accustomed to the practice of that tongue".

Back in Dublin he did some portrait work, but was disappointed by the lack of patronage. Somewhat depressed, he set out for London, hoping for greater success. This he achieved in no small degree. Travel, however intrigued him. We find him going back and forth to India, China and Spain. On one such trip to India the ship he was on was captured by the French and Spanish fleets. Hickey ended up in Cadiz. He was released shortly afterwards, but instead of returning to England, he made his way to Lisbon. Happily for him commissions for portraits began to pour in so he stayed there for about two years. In September 1783 he set sail for India and established himself in the fashionable area of Calcutta. Other journeys followed, including a visit to Dublin, the city of his birth. Eventually he made his home in Madras, with his two daughters, and died there at the age of eighty-three, preserving his faculties to the end.

In this three-quarter-length portrait our attention is riveted on the heads of the children. The artist has put all his skill, effort and care into the painting of their beautifully rounded eyes, delicate skin tones, and silken hair. Other parts of the picture, including the children's arms and hands and their white dresses, adorned with pink and blue sashes, have been treated more loosely and sketchily. The orange, of course, is a pivotal point in the composition. Whether it was a deliberate ploy by the artist to focus our attention, we do not know, but by its position, colour and perfection it catches the eye and serves as an interest to the children and to us, the viewers.

Like the great teacher, artist and orator that he was, Jesus also used powerful images and elements of surprise to make a point or convince his hearers of a truth. One day when his disciples were hotly disputing who would be the greatest in the kingdom, "he called over a little child, stood him in the midst and said: *I assure you unless you change and become like little children you will not enter the kingdom of God"* (Matt 18:1)

Oil on canvas 98 x 80cm
National Gallery of Ireland Collection
Photos © National Gallery of Ireland

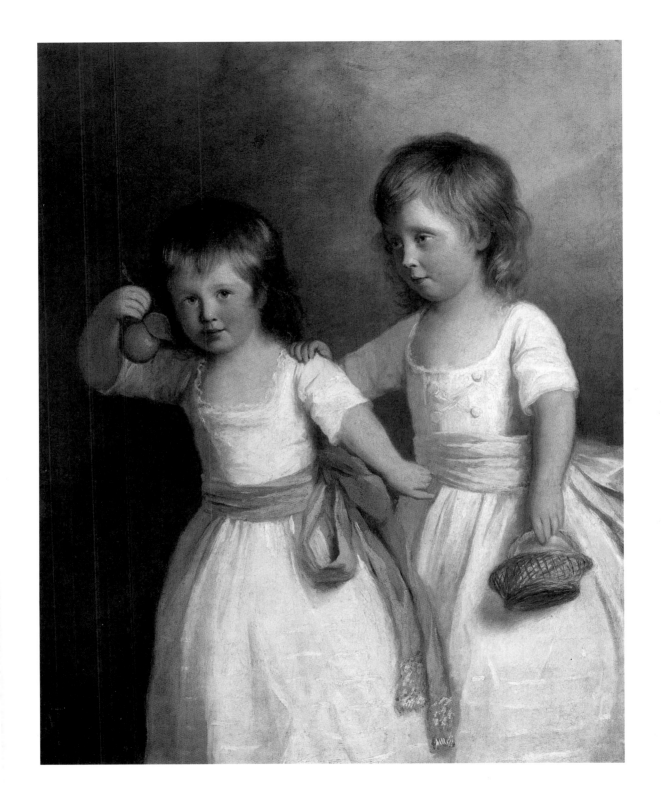

COCKLE PICKERS
by Joseph Malachy Kavanagh RHA
(1856-1918)

While Dublin has an extensive coastline on its eastern side, the inlets, coves and sandy beaches are comparatively small. Joseph Kavanagh, however, has managed to convey, in this painting, the impression of immense space by using a very low horizon and by placing his figures in the middle distance, under the dark canopy of cloud.

It is an impressive painting – good composition, distinctive tonal values and varied textures. The colour scheme is warm and subtle. The sky is powerful with its dark mass of cloud on the right, the paler clouds on the left and in the centre the warm light of the sun. The sandy beach is aglow with yellows, ochre and umbers. The two women, bending to their task, are thrown into silhouette as morning breaks.

Kavanagh may have been academic in his approach to landscape painting but that did not prevent him from developing a distinctive style. Transient light intrigued him. The changing nature of Irish weather gave him ample opportunity to study this constant fluctuation and he succeeded in capturing it with his brush. For a time architectural subjects became the focus of his attention, especially during his time in Belgium, where he had gone in 1882 as a student with his friend Walter Osborne, to further his studies. It is probable that they went together to Brittany and visited Quimperle, Pont-Aven and Dinan. It was at Dinan that Kavanagh painted *The Old Convent Gate*.

On his return to Ireland he taught for many years in the RHA School in Dublin – a popular and respected teacher. Even when abroad he had kept in touch with the RHA, sending paintings to the exhibition year after year, from the age of nineteen. All in all he showed about 200 works. He was elected an associate member in 1889 and a full member three years later. In a sense, his life was bound up in the Academy. He was devoted to its affairs. He never married. When he was made Keeper in 1910 he moved into apartments in the RHA premises in Lower Abbey St. A tragic episode occurred at the height of the 1916 rebellion when he was working in the Council room. A shell exploded outside the window shattering every pane of glass and causing untold damage. Kavanagh remained at his post until fire broke out. As he fled from the burning building he was captured by the military and interned in the Custom House for one week. But it was the loss of the Academy paraphernalia and many of his paintings that caused him the most trauma. He died two years later in a Dublin nursing home, in 1918, aged sixty-two.

This painting of Kavanagh's prompts me to ask the age-old question: Where does such beauty and simplicity come from? Who created the world? This question has puzzled people down the ages. It puzzled Job and God asked him; "Job, have you ever in all your life commanded a day to dawn? Does a hawk learn from you how to fly?" It puzzled Augustine in the 4th century. It puzzled Thomas Aquinas in the 13th century. It puzzles scientists today, as they probe into the mystery of the universe, as indeed they should. But regardless of what scientists may discover, my faith tells me that God, who is before all time, made the world.

"Lift up your eyes and look,
Is there any God except me?"
(Is 4:44)

Oil on canvas 58 x 77cm
AIB Art Collection

THE BIRTH OF A CHESTNUT TREE
by Richard Kingston RHA
(1922-2003)

In this painting of a nascent chestnut tree Richard Kingston has used repeated shapes and varied textures, based on the form of a chestnut. But it is the shining brown seed, nestling in its womb-like sheath of white velvet and surrounded by the spiky, green mantle, that is the visual fascination for the artist. The outline of the rough covering merges with the green of the tree on which it grows. As the shapes converge towards the centre their outlines become sharper, drawing the eye of the beholder to the core, the nucleus of a new life, that will one day fall to the ground and produce a new tree whose boughs will, one day, reach up to the heavens and produce flowers, fruit and seeds again.

Richard Kingston loved nature with the wonder of a child and the questioning of an informed adult. After a happy boyhood, working with horses on the family farm in Co Wicklow, he studied Arts and Engineering at Trinity College, Dublin. On qualifying, he moved to London, where he worked as a teacher and designer. From an early age, however, he had an urge to paint, so when he returned to Ireland in the late fifties, he embarked on a full-time career as a painter. For many years he exhibited at the Richie Hendrick's Gallery, at the RHA and at other venues until he opened his own gallery, "The Wellington Gallery" on Wellington Road, in 1970. It was there that I met him when he had begun his famous series of paintings based on the landform of The Giant's Causeway in Co Antrim. This extraordinary rock formation, shaped like hexagonal columns of varying heights, inspired him to produce an impressive body of work, which according to the art critic, Aidan Dunne, will stand as his finest achievement.

Always, it was an investigative approach that he took to nature. He pondered its mysterious workings, rather than dwelling on the external appearances influenced, no doubt, by his university studies. What is going on, and why? In the gospels we learn that Jesus, too, had a childlike sense of wonder at the marvels of nature. He was keenly aware of the world around him and constantly referred to the birds of the air and the flowers of the field. We are left with this major problem of the mystery of the evolving universe, that universe which is neither rigidly controlled nor abandoned totally to chance. We are one with all natural things – birds and beasts, fish and fowl, plants and planets. This oneness, leads to oneness with God, who is present and active in the here and now. He does not dwell in a distant realm, looking down on his creation like a benevolent ruler. He is, and he is one with us.

Listen, my people, and I will speak.
I am God, your God. (Ps 50:7)

Oil on board 30 x 24ins
Private Collection

STUDIO GARDEN
by William Leech RHA
(1881-1968)

The shaft of sunlight piercing the gap between the walls of the house and the studio, transforms what could be drab and ordinary into an interesting tapestry of shapes and colours. William Leech saw with an artist's vision the possibilities of a painting behind the simple things of everyday living. Here in his studio garden, he looks at the line of clothes and sees in its diagonal direction a focal point for an interesting composition. The strong evening sun glows golden on part of the grass, leaving large sections in shadow. It was these shapes of light and shadow that fascinated Leech. He painted with short brush strokes, using tones of yellow for sunlight and blue-green for the shadow areas. Though there are no people in the painting there is an atmosphere of home and happiness here. It echoed his own happiness at this time. He had married May Botterill, the love of his life, in April of that year 1953. They were both in their seventies and were living in Candy Cottage, near Guilford, in Surrey.

William Leech was born in Dublin, in 1881, at 49 Rutland Square, of well-to-do parents. His father was Regius Professor of Law at Trinity College. On leaving St Columba's College, Rathfarnham, William studied art, first at the Metropolitan School of Art and then at the Royal Hibernian Schools under Walter Osborne from whom, he said, he learned more about painting than from any other teacher. Leaving Dublin for Paris in 1901, he attended the Academie Julian for about two years. From there he went to Concarneau in Brittany. The congenial climate of this corner of France and the unspoilt landscape of its surrounds suited his temperament. His brushwork became freer and his palette lighter, paving the way for his colourful, impressionistic paintings of the 1960s.

When he returned to Dublin, to his parents' home in Morehampton Road, Donnybrook, he had acquired a sureness of touch and a mastery of composition. He became a regular contributor to the RHA exhibitions and was made a full member of the Academy in 1910. Shortly afterwards, his parents moved to London. William followed them and lived there for over forty years, with occasional trips abroad.

Experience had taught Leech that simplicity was best. "I am painting very simple things", he wrote to a friend. "Choose simple things: they are the most interesting."

In the spiritual life, also, simplicity is best. Very few of us are asked to perform heroic deeds or to travel to distant lands to preach the gospel but we are asked to cross the road to help a neighbour.

*"Share your bread with the hungry, and
shelter the homeless poor.
Give clothes to those who have nothing to
wear and turn not from your own kin.
Then you shall call and the Lord will answer"
(Is 58: 7)*

*Oil on canvas 78 x 67.5cm
AIB Art Collection*

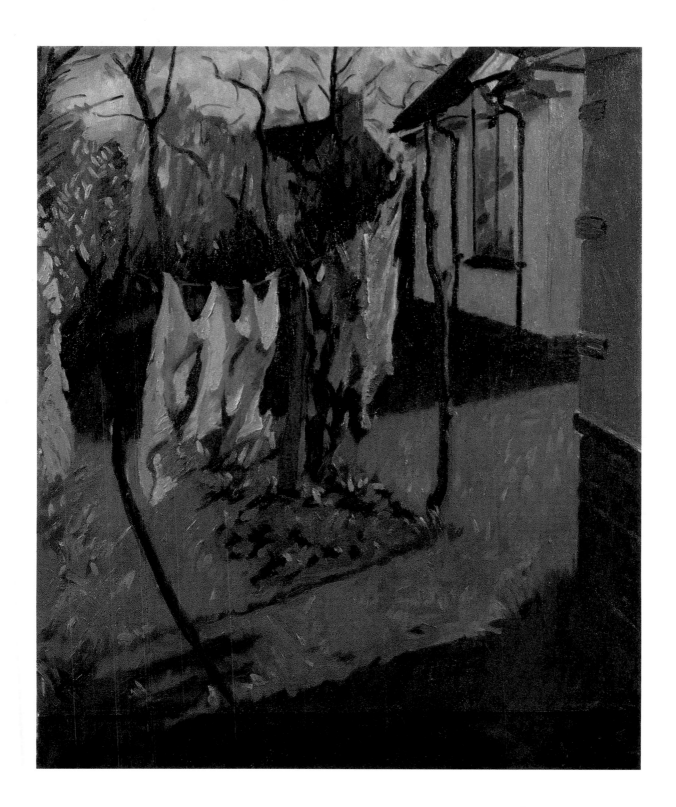

NURSING SISTERS, BEAUMONT HOME
by Patrick Leonard HRHA
(1918-2005)

Artists live in the same world as the rest of us, but they see that world differently. We might look at the sky and think that it is going to be a fine day or it is going to rain. The artist looks at the same sky and marvels at the changing shapes of the clouds. Patrick Leonard saw beauty in a bus queue! His paintings were inspired by everyday events. He sketched the people and the things around him, in a train, at the beach, wherever he was, at home or abroad, or even sick in hospital. These sketches were later used as starting points for finished oils. He painted because he loved to paint, not to be acclaimed by others, and so remained true to himself. He did receive acclaim when he was chosen to represent Ireland at the Olympic Games Exhibition in Helsinki in 1952, with an oil painting entitled *Tennis Players*. His painting career began when he attended the Metropolitan School of Art and came under the tutelage of Sean Keating and Maurice MacGonigal in 1936. A painting of his was accepted by the RHA as early as 1941. The following year he was offered an honorary membership.

Between 1953 and 1982 he taught art in different schools and colleges around Dublin, ending up in the Mercy College in Coolock, where he spent many happy years. Unfortunately his work of painting and teaching were often interrupted by bouts of illness, but he never stopped sketching. Numerous trips to the Beaumont Home to visit his mother there, gave him the opportunity to study nurses in their daily lives and to appreciate their dedication to the difficult tasks of nursing. When he chose to depict them in paint he eschewed the glamorous image and showed us their life in the raw. The three nurses here, escaping from the relentless round of dispensing drugs, dealing with recalcitrant patients, constantly on the go with bed pans and bed making, are women with sore feet and weary legs – solid, caring, reliable women. The artist poses them with feet apart, folded arms and bent backs, relaxing in the hospital garden, with the wind blowing through their headgears. Their place in the composition might appear to be accidental; a closer look reveals an interesting arrangement. Two standing figures are placed at the golden section, while the third figure, stooping to admire the pink roses, leads the eye across the canvas, cutting the curve of the flowerbed and linking the two sides of the painting. To add sparkle and emphasis the white uniforms are set against the silver-grey of the path and the dark bushes in the background.

All of us needs to give ourselves ritual rest, to be still, relax, listen and pray, to let the gentle wind of the spirit of God blow over us and through us, so that we may be open to that same Spirit.

Spirit of the living God fall afresh on me

Oil on wood 16 x 20ins
Private collection

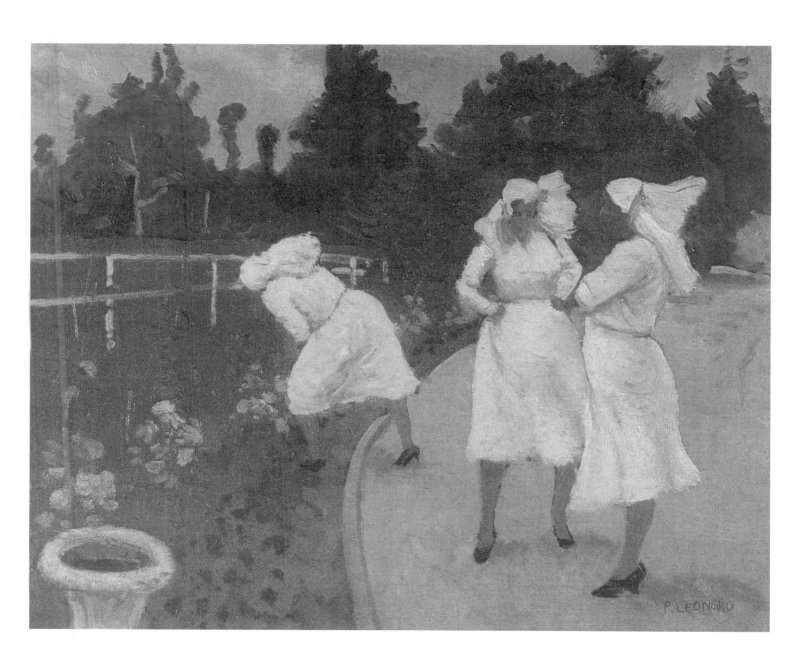

THE FOX
by John Luke RUA
(1906-1975)

One of eight children, John Luke followed his father into the Belfast shipyards at an early age and worked there as a heaterboy. His exceptional art ability soon became apparent, and with his father's encouragement he attended the Belfast School of Art for evening classes. A Dunville scholarship enabled him to travel to London, where he enrolled in the Slade School of Fine Art, under Professor Henry Tonks. The tuition he received there had a vital and lasting influence on the sensitive boy. His approach to painting became more and more meticulous. From the first conception of an idea to the faultless finish of the final stroke, Luke worked long and hard, with total concentration, to achieve the perfect picture as he saw it. He was preoccupied with technique, and spent hours preparing his support. The underpainting was usually in tempora, and on this he built up the decorative formalism with glaze after glaze of oil paint. The end result was one of intense luminosity. This meticulous approach was in keeping with his character. It showed itself even in his ritual for shaving! He was a tall, hansome man, well built, but thin, the result of a self-imposed abstemiousness in food. Cautious by nature, he was slow to make friends and became quite solitary.

All artists put something of themselves into their work. In this painting we can see the tidy, precise, even-tempered Luke concentrating on the perfection of each brush mark, carefully placed, every tonal curve consciously shaped, to set up the rhythmic force of this deceptively simple landscape. Shape echoes shape, curves are complimented by the perfect rectangles of the houses. Amid the tranquil beauty of the countryside a threatening presence is moving. The swift progress of the fox at the bottom left-hand corner adds another dimension to the painting. He is there, he is important (the work is named after him) but he is easily missed. Now you see him, now you don't. He is so integrated into the design and composition that he could go unnoticed.

The word-pictures painted in the parables by Jesus are like Luke's paintings. At first sight they seem to be easily comprehended – a woman who is constantly losing things, another woman famous for her bread making, a man who gambles all he has in his quest for gold, farmers sowing seed, fishermen hauling in their nets full of diverse fish. The situations are easily recognisable by us as they were by the people of Galilee. But to discover the hidden meaning needs more careful consideration. Jesus said: *I use parables because they look, but do not see, they listen but do not hear or understand* (Matt 8). Every word that Jesus spoke was filled with wisdom and truth, and we need to think deeply in order to find a meaning behind the words.

Oil on tempora 38 x 54cm
© The Estate of John Luke
Collection: Ulster Museum

AT THE SEASIDE
by Gladys McCabe RUA
(b. 1918)

Gladys McCabe loves to fill her canvases with figures. She chooses subjects that lend themselves to this possibility: street and beach scenes, race meetings, fair days and market places. In this seaside scene she arranges the children all over the golden strand, contrary to her more usual practice of overlapping the figures. Some sit on rocks, others move forward eagerly to find sites for their sand castles. The two ponies form the centrepiece of the composition, framed by the children and by the adult figures in the foreground. The sea is laid in with a few brushstrokes in blues and greens, with a dash of white to suggest waves. Short shadows suggest overhead lighting from an early summer sun.

The artist hails from Co Antrim. She was born in the small town of Randalstown into a family with an artistic heritage. Her mother was a designer in the family linen business. Her father, George Chalmers, a descendent of the 18th century Scottish portrait painter, was an officer in the Gordon Highlanders and also an artist. It is not surprising that Gladys grew up with the smell of paint and the feel of a paintbrush from her cradle days. Nor is it surprising that she received encouragement from her family to develop her artistic talents, though her father died when she was twelve years old. In her school curriculum also, art and music played an important part. She submitted drawings at a young age to the Royal Drawing Society's Examination with outstanding success, and when she left school she attended the Belfast College of Art, with the support of her mother. She studied painting, fashion design and pattern making and won the prize for "Best All Round Work".

In 1941 Gladys met and married Max McCabe, a true soul mate, who shared her love of painting and music. There was, between them, a strong empathy. They travelled together, they painted together, and they exhibited together. They sought to extend their knowledge and love of art to others by lectures with demonstrations, accompanied by piano and violin.

The charming, friendly personality of Gladys finds an echo in her paintings. There is in them, discernible love and respect for people, an almost spiritual quality, rare today. She paints portraits and still life, but is best known for crowd scenes and group paintings. "Somehow", she says "we all overlap and affect each other in strange, inexplicable ways."

We overlap one another! What a wonderful way of expressing our inter-connectedness. We have to ask ourselves how we behave to those around us, to those above us and to those below us. Do we love, respect and tolerate them? Jesus did just that. He went about doing good, healing all who sought his help. He never coerced people, but respected their freedom. In his book *Jesus Today*, the Dominican, Albert Nolan, expresses the same truth. "In reality we are all interconnected and interdependent. None of us could survive without others – we belong together. We are one."

Oil on canvas 16 x 20 ins
Private Collection
© The Artist

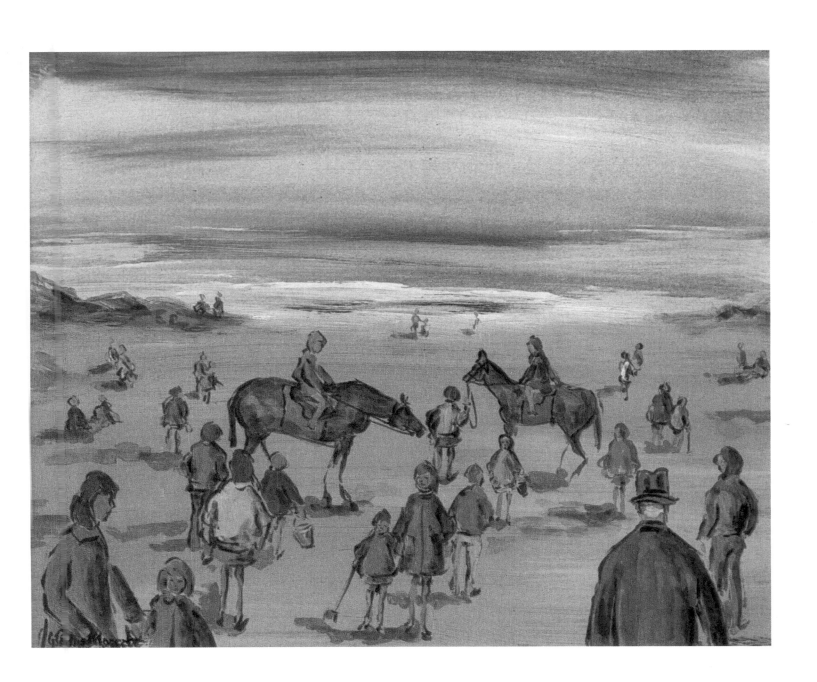

DOCKERS
by Maurice MacGonigal, RHA
(1900-1979)

An impressive painting. The powerful composition, strong lines and simple, striking colour scheme, enhance the skilful drawing. Who painted a picture like this? It was surely a man who knew Dublin and its dockside, a man who was passionate about social issues, a man who was an artist – his name, Maurice MacGonigal.

The family came from Sligo, but Maurice was born and educated in Dublin. After his schooling at the Christian Brothers' School in Synge Street he went to work in the stained glass studio of his uncle, Joshua Clarke. In 1920, because of his active involvement in the struggle for Irish independence, he was imprisoned for two years. On his release he resigned from the IRA and continued to work for his uncle, but attended the Metropolitan School of Art at night. The Taylor Art Reward enabled him to leave the studio and pursue the study of painting full time. He found this form of art more congenial than the restricted discipline and confining elements of stained glass. It was better suited to his talent and temperament.

In a visit to Holland in 1927 he was deeply impressed by the Dutch artists of the 17th and 19th centuries. So impressed was he by the paintings of Van Gogh that he declared, "I have not seen a modern that could paint near him in intensity." He painted intensely himself on his return to Ireland, concentrating on keenly observed landscapes as well as many genre paintings and portraits. He became highly successful in his work. In 1937 he was appointed professor of painting at the Royal Hibernian Academy School, and became President of the Academy in 1962, in succession to his one-time tutor, Sean Keating. When he died in 1979 he left a legacy of a visual identity for independent Ireland.

The subject of our present picture is an unusual one for MacGonigal. The dockers, or "button men" as they were sometimes called, stand in groups before a ship, waiting to be hired. The young man in front, cap in hand, resents the shame of standing in the market place. The older men on either side have a calm air of resignation, accepting their lot when they are unable to change the social structure that created it.

When we are up against injustice, acceptance is sometimes the answer, but we cannot be complacent. Jesus took an uncompromising stance against the oppression of his day. He condemned the system that gave the rich such power over the poor. Poverty and unemployment existed then as they do today. The situation repeats itself in all places and in every age. *"The poor will be always with you"* (Matt 26:11). There is a responsibility on each of us to seek a solution, in whatever way we can.

God grant me
The serenity to accept the things I cannot change;
The courage to change the things I can;
and the wisdom to know the difference.

Oil on canvas 16 x 20ins
Collection: Dublin City Gallery, The Hugh Lane

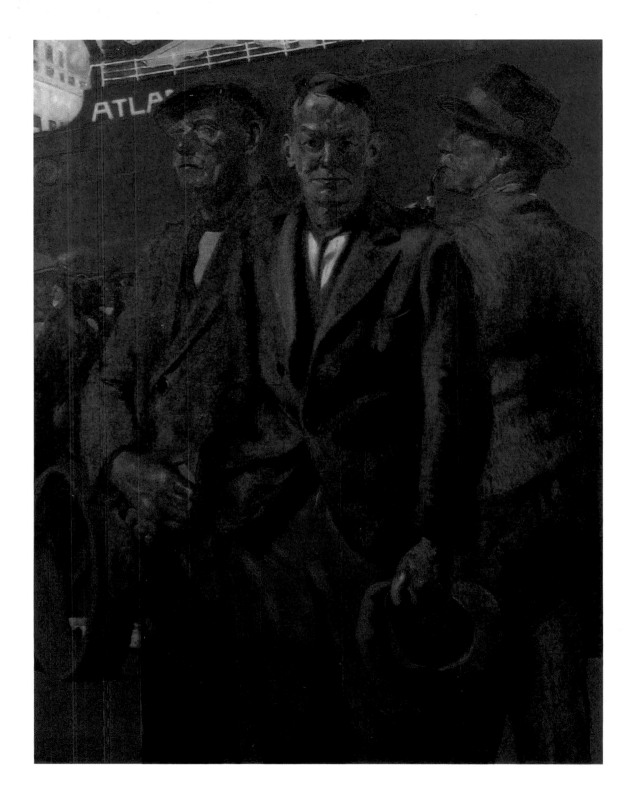

DUBLIN BAY GOURMANDS
by Norah McGuinness HRHA
(1901-1980)

This lively picture was painted by one of the great women pioneers of Irish modern painting, Norah McGuinness. She was born in Derry but came to Dublin in 1921 when she was eighteen years old, to attend the Metropolitan School of Art, on a three year scholarship. Her tutors were Patrick Tuohy and Harry Clarke. In the subsequent years, she had to support herself and, having no inclination to teach, she accepted many commissions to illustrate books and to design for the Abbey and Peacock Theatres. As soon as she could afford it, she went to study art in Paris, in the studio of the Cubist painter, Andre Lhote, on the advice of Mainie Jellett. This visit was of short duration as she realised that she had little to gain from Lhote's approach to painting at that time. Visits to India, London and the USA followed. She had her first one person show in New York in 1939. On her return to Dublin a year later she was employed by the firm of Brown Thomas, Grafton Street, as their window dresser, a position she held for thirty years. She continued to paint and exhibit in various venues. She was one of the founders of the Irish Exhibition of Living Art and took on the role of President after the death of Mainie Jellett in 1944. In this capacity she was "... vocal, articulate, tough and charming ..."(Dorothy Walker), and she held the position for over twenty years. She was elected honorary member of the RHA in 1957 but resigned in 1969.

Her fascination with the scavenging sea gulls, screaming, twirling and encircling the mud flats and sand pits of the Dublin docks, resulted in many fine paintings. The artist has used bold brush strokes in this spontaneous and dramatic painting. It is made up of harmonious, echoing shapes, and strong contrasts, light and dark, movement and stillness, of things near and far away. She ignores unnecessary detail and concentrates on the essential of the scene. The gulls are free, coming and going as they will, unencumbered by rules and regulations, while the shipping port in the background is constrained by timetables, tides and tensions, government laws and commercial interests.

Looking at this painting makes me aware that, in our span of life, we may expect some carefree days of sheer happiness, other sad, dark days of dull, dreary conformity. Life, indeed, is better understood in terms of opposites. It takes darkness to appreciate light, coldness to appreciate warmth, constraint to appreciate freedom, sorrow to appreciate joy. To get the balance right we need a wisdom and strength beyond ourselves and so we turn to God, who is wisdom itself. *"Be still and know that I am God" (Ps 46).*

"See I am God,
See I am in all things.
See I can do all things."
Julian of Norwich

Oil on canvas 50 x 76.2cm
Private collection
© The Artist

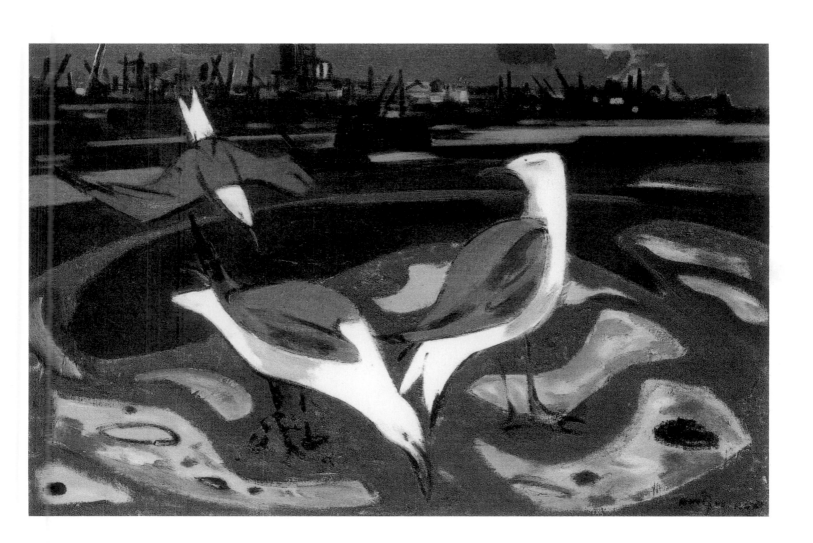

MORNING GALLOP, LAYTOWN
by Cecil Maguire RHA RUA
(b. 1930)

This painting comes from the brush of Cecil Maguire, born in Lurgan, Co Armagh. He pursued academic studies, graduating from Queen's University, Belfast in 1951, before embarking on a career as a painter. Teaching was his preferred option and English was his subject. His success as a teacher was recognised when he was made Senior English Master at the college in his hometown. More and more, however, painting assumed for him a greater importance until finally, at the age of 51, he resigned his teaching position in order to devote himself to painting fulltime. Already, he had become an Associate and then an Academician of the Royal Ulster Academy. About this time he was also exhibiting in the RHA in Dublin and was subsequently made a full member of the Academy. Like so many artists before him he was drawn to the West of Ireland, and it is there in Roundstone, Connemara, that he lives for most of the year.

Judging from this painting, he also enjoys his visits to the East coast. Laytown, a small seaside resort in Co Meath, has a three mile stretch of golden sand and has been made famous, worldwide, for its once a year horse-racing event on the beach. The event is unique, not only for its antiquity, but because it is the only beach race run under the Rules of Racing. The Maguire painting shows us a friendly morning gallop in preparation for the big day. Horses and riders are disposed in such a way on the canvas as to create a perfect compositional balance. The rider on the right and the more distant horse and rider, moving in the opposite direction, balances the bloc, formed by the two foreground riders and their reflections in the pools of the incoming or perhaps the receding tide. The stationary group on the left, with their reflections, completes the composition. This is a beautifully designed painting. Blue is the dominant colour. The artist has used green blue for the sky, cool blue for the tidal pools, blue-black for the horses, blue shadows on the wet sand, and touches of blue on the jockey's vests, and then has riveted our attention by the unexpected splash of red on the foremost rider.

Equestrian sport has been a favourite one in many nations, not least in our own, over the centuries. The elegant beauty of the horse, its power and its speed make it one of creation's wonders considered by some as the embodiment of the spiritual, "one of the primordial symbols of life". We find references to it even in the Bible, especially in the Old Testament. Jewish scribes were keenly aware of the horse's strength and courage in battle, but it was to God that they always attributed their victories. *"The horse is equipped for the day of battle, but victory is the Lord's"* (Prov 21:31). The Psalmist repeats the same sentiment, *"Useless is the horse for safety: great though its power it cannot save"* (Ps 33:17).

Oil on board 46 x 71cm
© *The Artist*

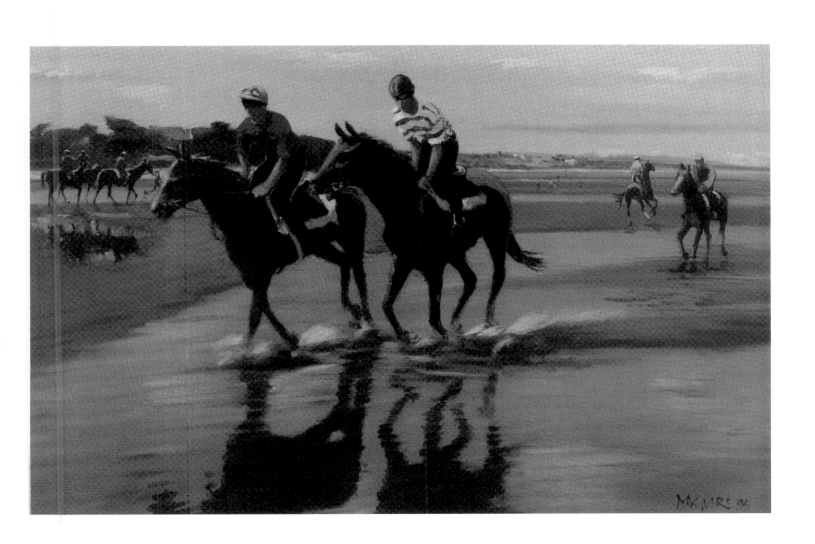

MILITARY MANOEUVRES
by Richard Moynan RHA
(1856-1906)

Looking at this picture, I was reminded of a bitterly cold night in Red Square in Moscow in the winter of 1983. A group of students and staff from St Patrick's College of Education in Drumcondra, Dublin had arrived in Russia for their annual cultural tour. On that first night a few of us walked to the famous square, only a short distance from our hotel, to see the changing of the guard at Lenin's Mausoleum. One of the students started to imitate the goose stepping of the guards. She was fascinated and perhaps a little amused by their military precision, but it was a dangerous thing to do at that time. The small bare-foot boys in Moynan's painting are doing much the same thing. They have put together a motley set of drums and pipes, as well as one or two home-made hats. The boy on the right foreground has managed to get hold of a magnificent helmet. Each child is painted as an individual, with empathy and humour. On the left a guard of the 4th Royal Irish Dragoons, in full uniform, with a stern, superior mien, is walking out his well-dressed lady in the village of Leixlip, Co Kildare, while the little girl in ragged clothes looks on wistfully. These were the kind of scenes and the kind of people the artist loved to paint. He had an unlimited supply of models in the villages of Ireland.

Richard Moynan's own family was middle-class. They lived on the South Circular Road in Dublin. On leaving school he enrolled in the Royal College of Surgeons to study medicine but he never completed the course. He chose instead to pursue a career as a painter. He was a talented and industrious student and won many prizes and a scholarship which enabled him to travel. He went to Antwerp in Belgium with Roderic O' Conor, and enrolled in the studio of Charles Varlet. Six months later he was in Paris, then the centre of the artistic world. After two fruitful years there, during which time he sent several canvases to the RHA exhibitions, he returned to Ireland.

Though artists were not taken very seriously in his native land, Moynan's prospects were good. He was an excellent portraitist. His sketch books, now in the National Gallery of Ireland, are testimony to his ability as a draughtsman in pencil, pen, chalk and watercolour. He also drew cartoons under the pseudonym of "Lex". He continued to exhibit regularly at the RHA and was made a full member of the academy in 1890. Sadly, he threw away what might have been a brilliant career, with his addiction to drink. Not only his prospects, but his health was destroyed. He died in 1906 at the age of fifty.

We tend to imitate those whom we admire and love – parents, heroes and heroines, adventurers and achievers in sport, etc. Jesus is surely the ultimate hero and exemplar. He "did all things well", but he chose poverty, not wealth; service, not selfishness; suffering, not pleasure. His way is through the narrow gate, the gate that leads to eternal life and happiness.

Oil on canvas, 148 x 240cm
National Gallery of Ireland Collection
Photos © National Gallery of Ireland

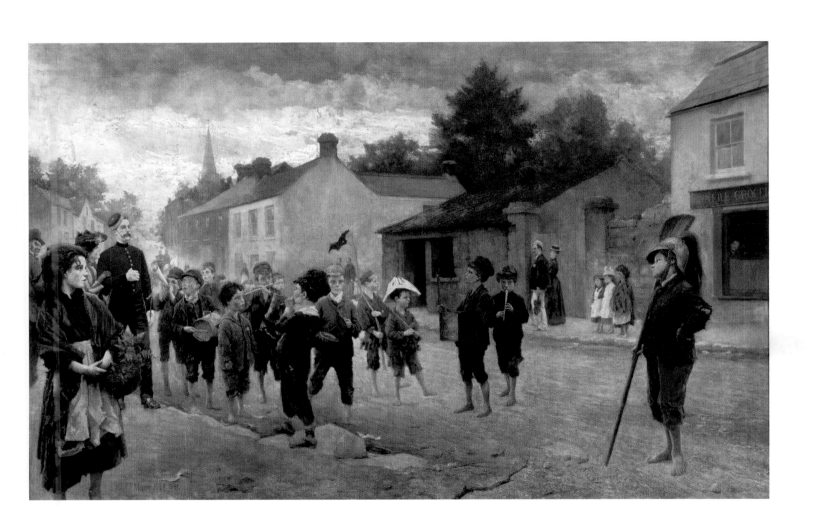

PAROQUETS
by Edward Murphy
(c. 1796-1841)

Colour, texture, design, they are all here in this appealing, competent, painting. The birds are placed, in a triangular shape, against a beautifully painted sky, within a stone archway covered with ivy. Edward Murphy has arranged all the parts into a near perfect composition. But it is especially colour that makes this painting so visually exciting. The vivid red, yellow and blue of the Scarlet Macaw contrasts vividly with the white of the Cockatoo. The green feathers of the little Paroquet, with its red beak and neck ring, offer us strong complimentary colours, as does the foliage and the flowers in the surround. One can only marvel also at the artist's skill in depicting texture with such tactile sensation – the soft silky feel of the feathers, the hardness of the beaks, the roughness of the old tree, the smoothness of the stone and the shiny surface of the ivy. Earlier in his career he had emulated the Dutch masters in their paintings of flowers and still-life. Such competence in the handling of paint could only come with constant practice and acute observation. He achieved this skill and competence in a relatively short space of time for he died young, terminating his own life in 1841, at the age of forty-five. Other than this tragic event there is little known about Edward Murphy except that he taught art for several years, after completing his studies at the Royal Dublin Society School.

By choosing these birds as the subject of a painting, he was pandering to the art buying public at the beginning of the 19th century. Parrots had become the popular possession of the upper classes. Those who could afford these exotic birds were intrigued with the idea that they could be taught to mimic the sounds of the human voice. They could also learn short phrases, and repeat them endlessly to the delight of their owners. Of course it was an illusion that these repetitive words expressed emotion or formed a bond with the listener.

Are we a bit like parrots when it comes to praying, repeating words and phrases while our thoughts are flying in all directions? If my heart is not praying, my tongue is wasting its time! *"This people honours me with their lips but their heart is far from me"* (Mk 7:6). However if we are sincere in our asking; *" The Spirit helps us in our weakness for we do not know how to pray as we ought; but the Spirit himself makes intercession for us with inexpressible groaning"* (Rom 8:26).

Oil on canvas 85 x 610cm
National Gallery of Ireland
Photos © National Gallery of Ireland

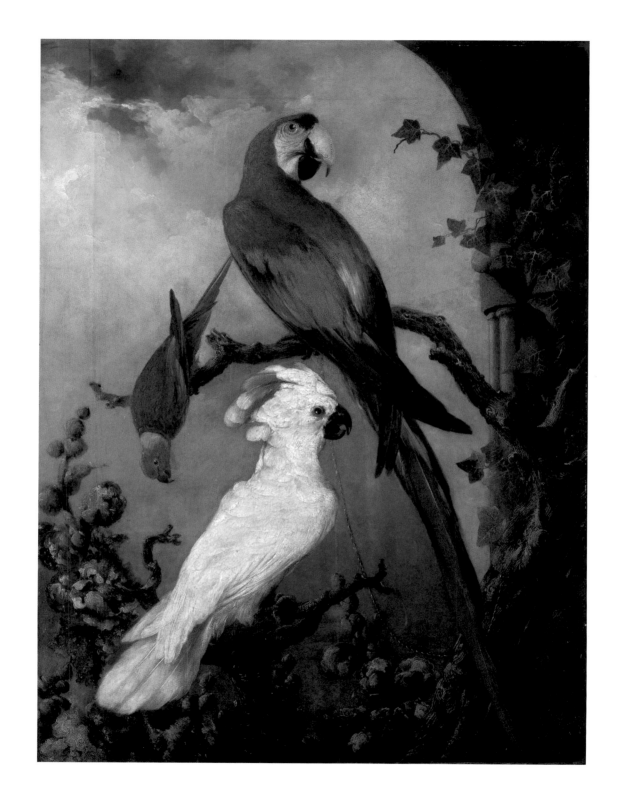

THE CARD PLAYERS
by Eileen Murray
(1885-1962)

When this painting was exhibited in the Waterford Municipal Art Gallery after the artist's death, it was voted the most popular painting on show. The four characters are old hands at an old game. They are gathered around a table in what looks like a barn, lighted by one small window high in the wall. Through this window a shaft of light illumines the face of the man on the left, catches the side of the face of the central player and the handful of cards rather than the face of the man on the right. Light also touches in spots the young man who is standing. That window with the skimpy curtain is no accident. Artists have used the ploy for a very long time to create nuances of light and shade. The composition is reminiscent of one of Cezanne's paintings also entitled *The Card Players,* but the faces in Murray's version are unmistakably Irish. These are real people, people the artist must have known. With deft free strokes of her brush she has painted their personalities and suggested that tense, decisive moment that can make a game so memorable! But it is the use of light that lifts this painting into a minor masterpiece.

Eileen Murray's name does not loom large in the history of Irish painting, but she has left behind many memorable canvases, including *The Card Players* featured here. Nor do we know much of her personal life or family background. What we do know is that she was born in Templemore, a small town in Co Cork, in 1885 and given the names, Eileen Frances Jane Bunbery. Her surname was Chester. As a young woman she studied painting with Stanhope Forbes at the artists' colony at Newlyn, Cornwall, on the extreme south west of England.

At the age of twenty-three she married Major FSJ Murray who at that time was positioned in India. It was there that they set up their home and lived for many years. While in India she painted and exhibited with a good deal of success. Returning to Ireland, twelve years later, she lived at Mosstown House, in Kenagh, Co Longford. She enjoyed painting still-life and landscapes but she excelled in figurative work and portraiture. She was a regular exhibitor at the RHA and other venues. In 1947 she moved to Killiney, Co Dublin and died there in 1962.

It is not only the artist who loves light. For anyone a ray of sunshine can lighten up a dull day, a glimmer of light in a dark tunnel can lift the heart and presage a safe return home, so let us walk in the light and thank God for it.

"But if we walk in the light, as he is in the light, we have fellowship with one another, and the blood of his Son Jesus cleanses us from all sin" (1Jn 1:7)

Oil on canvas, c. 1940
Signed E Murray
Donated to the Waterford Municipal Art Gallery
by Arnold & Hilda Marsh, 1940

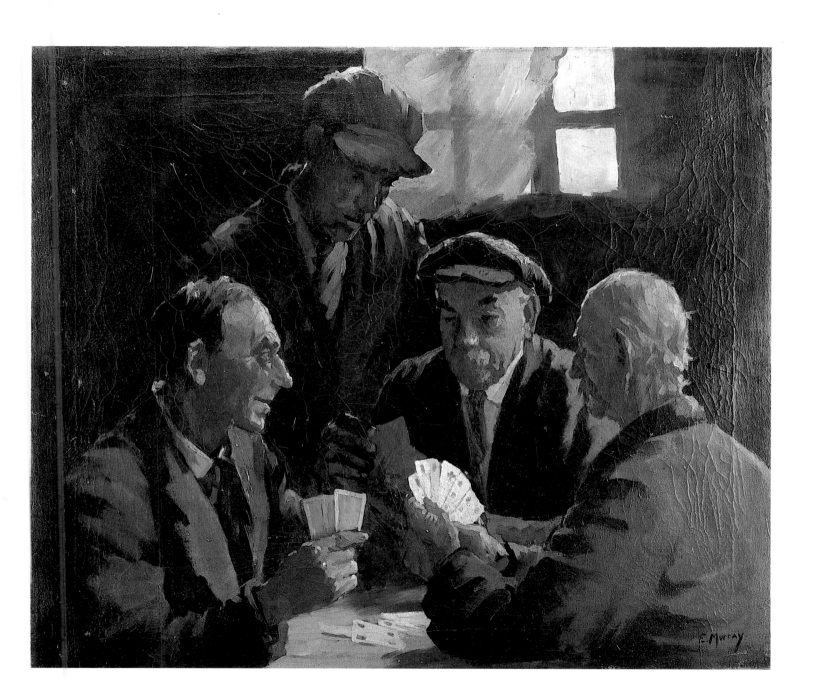

WOODED LANE AND COTTAGE
by Thomas Nisbet RHA
(1909-2001)

For those who enjoy the yearly RHA Exhibition in the Gallagher Gallery in Dublin, the name of Tom Nisbet is indeed a familiar one. He first exhibited at this major exhibition in 1935. From the time he was made a full Academy member he used the privileged quota of seven paintings each year in an unbroken record until 2001, the year he died at the age of ninety one. Early in his career he became a popular and esteemed member of the Watercolour Society of Ireland, as well as a regular contributor to The Dublin Painting and Sketching Club.

With his very large output, the level of excellence was not always the same. Wooded Lane is a particularly good example of his best work. It pictures a simple rural laneway, flanked on both sides by trees, with a small cottage on a lower level of the sloping bank. The inspiration for the painting was probably some familiar spot on the outskirts of Rathfarnham – a place where people passed on foot, bicycle or car, and thought no more about it. It took the eye of the artist to see its potential for a painting. He has caught the feeling of lush, summer growth and the majesty of the trees. There is a nice balance of light and dark passages; the mass of foliage is suggested with contrasting values of greens. A magic touch of yellow in the old pine tree echoes the dull yellow of the cottage walls. There is spontaneity in the painting and liveliness in the application of paint. It is both free and controlled.

Thomas Nisbet was born in Belfast, on 16 December 1909, one of four brothers, to Alexander and Annie Nisbet. His father, blessed with perfect pitch, worked as a piano tuner and repairer and was also a very good pianist. His son showed potential as an artist, but it was some years before he was able to embark on an artistic career. In the meantime he became a keen reader, built up a fund of general knowledge, and often expressed himself in writing with powers of description and ringing phrases. He left Belfast in 1931 at the age of 22 and came to Dublin. His first job here was with a motor firm, as a van driver. He transported motor parts back and forth to the west of Ireland by day and by night he attended the Dublin Metropolitan School of Art. Eventually he was able to work fulltime as an artist. In 1944 he married Kathleen Byrne and set up the Grafton Gallery in Dublin. In his kindly, generous way he helped many a struggling artist up the difficult hill of recognition, including Arthur Armstrong and Colin Middleton, both fellow Northerners.

In Nisbet's painting we cannot see what is beyond the bend in the road, just as we cannot see ahead on the circuitous road of our spiritual journey through life. But we keep going, knowing that the shape of our journey makes sense to God, who loves us and we trust him. He is with us every inch of the way, up every hill and around every corner though he is hidden from our gaze.

O Lord, give us wisdom and insight to know your purpose
and give us courage to follow where your Spirit leads us.
(Prayer of the Church)

Watercolour
Private collection

AFTER THE RAIN
by Gretta O'Brien
(20th Century)

The dark, vaporous clouds have dropped their moisture, and then parted and scattered, allowing the sun to burst through and envelope everything in its luminous light. The artist, Gretta O'Brien, has captured this magical moment with her brush. She was born in Cork and lived and painted there for many years. After attending the Crawford Municipal School of Art for a few years, she extended her horizons by travelling to Spain to study there and to gain experience. She also spent some time in France. In 1981 she moved to Dublin, and exhibited extensively in several galleries, especially in the Waldock Gallery in Blackrock, Co Dublin. She now resides in Greystones, Co Wicklow.

Over the years her work has gone through many phases, from representational to semi-abstract to pure abstraction. Recently she has returned to a more representational way of interpreting nature. In all her varied ways of working, there has been a consistency in her use of vibrant colours, together with a strong sense of design and pattern.

In this painting, Gretta gives us a glimpse into the enriching effect of a shower of rain on a section of woodland. She has used a subtle colour scheme of cool blues and greens, complimented by soft, glowing yellows – a fitting blend of colour for an Irish woodland in early summer, and one which helps to create a scene of unspoilt serenity and great mystery. Leaves raise their heads again, flowers give forth their scent, and hidden beauty is revealed – the eternal resurrection. What a difference a shower of rain can make!

We sometimes complain of rain here in Ireland. "I don't mind the cold, so long as it does not rain", is the kind of remark one often hears. However, beneath the grumbling and grousing, I am sure that most of us appreciate the need for rain, the blessings that it brings and the intolerable conditions that follow from its lack. Let us, then, rejoice in the rain, especially in those sudden, summer showers.

The coming of the Son of God into our world is likened to rain falling on the ground. A lovely description can be found in the Advent Liturgy: *He will come down into the womb of the Virgin, like rain gently falling on the ground.* He came and walked among us, and his coming was life-enhancing. He healed the sick by his touch, gave sight to the blind, hope to the sinner, strength to the weak, a reason for living to those crushed by adversity. He even raised the dead to life. He came, not with fanfare or fireworks, not in a mighty wind, but as the gentle rain from heaven. It takes some searching to find him. In stillness we will hear his voice.

Watercolour 16 x 20ins
Private collection

RED ROCKS NEAR PONT-AVEN
by Roderic O'Conor RHA
(1860-1940)

The artist who painted this small, vibrant, seascape was a man who was inclined to be introverted and solitary, but highly regarded as a pioneer of painting by his contemporaries and fellow artists.

He was Roderic O'Conor, born in 1860 in Milton, Co Roscommon. The family was of ancient Irish lineage and owned extensive property. His father, a member of the legal profession, became Justice of the Peace and High Sheriff of the County. Money was not a problem, so Roderic was sent to Ampleforth College, in England, run by the Benedictines, when he was 13 years old. An intelligent boy, he could have chosen to follow a legal career, but opted for art instead. As the family had moved to Dublin when Roderic was five years of age, he was able to attend the Metropolitan School of Art there after leaving school. He also spent a year at the Royal Hibernian Schools. In 1883 he went, with Richard Moynan, to Antwerp to study at the Academie Royale des Beaux-Arts. His return sojourn in Dublin was short. He had set his sights on Paris and travelled there in about 1887. From that time on he spent virtually the rest of his long life in the French capital or in the neighbouring countryside. The seaside village of Pont-Aven became one of his favourite painting places. Influenced by his fellow painters, he began to use innovative ways of applying paint and, responding to his environment, his palette became more high-key in colour. He owed much of this dramatic change, especially in his perception of colour, to Paul Gauguin with whom he had a close friendship. O'Conor was extremely well informed and knowledgeable about painting and its history. For over fifty years he witnessed rapid changes and development in Paris and in its environments and was well aware of the Post Impressionists, the Fauves and other movements, but he stood aloof and went his own way. Neither did he conform to pattern in his private life. He remained single, until at the age of seventy-three, he married his model, Renee Honta, who was also a painter, and they lived very happily together in Nuel-sur-Layon until he died in 1940.

The shore around Brittany was the scene for a number of small but powerful seascapes painted by O'Conor. He studied the way the sea sometimes pounded the rocks, churning itself into whirls of foaming water, or at other times appeared in milder mood. In this painting the artist has concentrated on the rocks, treating them with vigorous strokes of rich, thick, red and ochre paint. Long slashes of bright green and marine blue give sparkle to the sea, set against a paler green and yellow sky. It is unmistakably an O'Conor.

The sea is never still. Tides are timeless, yet set in time, never failing to come in and go out, at regular intervals; the pattern repeated day after day, year after year, since time began. We live in time, destined for eternity and time is short. Make time for God, for prayer, in the span that is yours. Open your hearts to him and his love will flow through you like a mighty ocean.

Oil on board 25 x 35.5cm
AIB Art Collection

EVENING
by Helen O'Hara
(1846-1920)

The sea can be calm and the sea can be rough. It can caress sandy beaches or beat against a rocky shore. It can be friend or foe. In its many moods it has held a fascination for artists. They have tried to capture, in pictorial terms, its peaceful tranquility under a blue sky, it's frightening, towering waves in a storm, or the patterns it makes as it flows and ebbs at the water's edge.

Helen O'Hara took her palette and paints on occasion to the woodlands and countryside of her homeland, but she was drawn back again and again to the sea. This is not surprising since she grew up at the edge of the ocean around Portstewart, in Co Derry. Her father was Rev James D. O'Hara of The Castle, Portstewart. Little else is known of her family circumstances or of her artistic training. It is on record, however, that she exhibited her work at the RHA exhibitions, at the Watercolour Society and the Society of Women Artists. Over a hundred watercolours of hers were hung between 1892 and 1913. Ten paintings, including this lovely image of the sea at eventide, were shown in 1893. She seems, also, to have had a continuous market in England. In her mid forties she left the north of Ireland and went to live in Lismore, Co Waterford, where she had some relatives. She died there in 1920.

This watercolour is one of many that she painted of the sea fringing the Giant's Causeway in Co Antrim, and is a very good example of her detailed and delicate touch – detailed but not fussy, delicate but strong. It shows too, her command over the difficult techniques of watercolour. Her use of subtle purples, pinks, ochres and umbers in portraying the early evening glow on the water and the patterned shapes of the changing flow of the advancing tide as it approaches the rocky shore, is masterly. The cliffs on the right add stability and balance, while the wheeling gulls create atmosphere and movement.

The sea played an important part in Jesus' missionary life. Several of his disciples were fishermen. He used their boats to preach to the crowds, and to cross and recross the Sea of Galilee. On one occasion a sudden and violent storm arose while he slept in the prow of the boat. Terrified, these hardy fishermen woke him, and he *"who assigned the sea its boundaries and traced the foundations of the earth"* (Proverbs 8:29) stood up and rebuked the winds and the sea and there was a great calm. The disciples were astounded. *"Whatever kind of man is this"*, they whispered, *"that even the winds and the sea obey him?"* (Matt 8:23).

Watercolour
The Gorry Gallery

OLD WOMAN BURNING LEAVES
by Frank O'Meara
(1853-1888)

Old and bent she sits on the bank of the river Loing. Her movements are slow, as she gathers the fallen leaves and throws them on the fire. In the quietness of the cold autumn evening, the orange coloured flame flickers in the foreground, adding a little movement to the overall stillness, and lights up the worn face with its warm glow. Though the scene is set in France, the mood of the painting has something of Celtic melancholy about it. Indeed it was painted by the hand of an Irishman, Frank O'Meara, who was born and grew up in Carlow. He is rather a shadowy figure in the world of Irish art, because he spent all his painting years in France. He started his art studies as a student in the *atelier* of Carolus-Duran in Paris, in 1873. This was a small newly opened studio frequented mainly by American and English students and a few French. He spent one year there before going to paint at Barbizon, outside Paris. In the summer of that year, a chance visit with a group of Anglo and American fellow students to Grez-sur-Loing, not far from the forest of Fontainebleau, decided the next thirteen years of his life. Though he returned to Paris on and off, this sleepy little village, full of atmosphere, became his base and provided him with the subject matter for painting. He worked at the edge of the village, in quiet woods, by slow streams or beside still pools. His output was sparse, perhaps one or two large paintings a year. He and his friends wasted a lot of time waiting for a grey day.

He is remembered by his contemporaries as a *"courteous and accomplished gentleman"*, with a melting voice, a warm heart and a sense of fun. He wore a blue beret on his curly head and a blackthorn shillelagh in his hand. It was in Grez, in 1880 that he met Belle Bowes. She modelled for him for some of his most important paintings. They formed a close relationship and became engaged. The engagement was prolonged because of financial restraints and then Frank contracted malaria on a painting expedition. This rapidly undermined his health, so that a few years later, he was forced to return to the family home in Carlow, suffering from exhaustion and fever. Belle stayed with him until he died on 15 October 1888, aged thirty-five.

A melancholy strain in O'Meara's character may have found an echo in the sad-looking, old French peasant, painted with such a subdued palette and thin application of paint. The tonal values vary little, except for that small batch of light in the water reflecting the low, autumnal sun. The style is not realism, nor is it impressionism. It is O'Meara at his best. The picture haunts me. There is something forbidding in the woman's bearing, her furtive gathering of the leaves and her dark staring eyes. She doesn't seem to be friendly. But one can be deceived by external appearances. She may be just lonely and cold, but with a warm, loving heart.

It is easy to be carried away by outward beauty or influenced by the trappings of wealth.

"Do not judge and you will not be judged; because the judgements you give are the judgements you will receive"
(Matt 7:1)

Oil on canvas 100 x 49cm
Collection: Dublin City Gallery The Hugh Lane

JESSICA
by Daniel O'Neill
(1920-1974)

This painting of Jessica is typical of the mature style of the painter Daniel O'Neill. Known to his friends as Big Dan, he was born on 21 January 1920, to grow up to 6'3" in height. He lived with his father, an electrician, and his mother, at 4 Dumsdale St, Belfast. Even while at St John's Public Elementary School, he was intensely interested in art, an interest inherited from his mother, a gifted draughtswoman. But practicalities came first and he followed in his father's footsteps into the electrical trade. While holding down a day job he dabbled in his spare time in watercolour without much success. He soon realised that to fulfil his ambition to become a painter, he would have to study techniques and constantly practise his art. He succeeded in getting a night-shift from 11 p.m. to 7 a.m. Each morning on returning home he painted for 5 hours, slept for 5 hours and painted again until it was time to go back to the night job. With an interruption for a honeymoon in 1942, this became the pattern of his life for about four years. He attended a few life classes in the Belfast College of Art and worked with Sidney Smith in his studio for a short time. Otherwise he worked on his own, painting on any surface he could find – money was very scarce in those days. O'Neill was advised to take the train to Dublin and present some paintings to Victor Waddington, who accepted them immediately, offered him an exhibition in his gallery and an allowance. This enabled O'Neill to give up his job and begin to paint full time. His first exhibition in Dublin was a huge success. It opened the door to eventual worldwide recognition. In the meantime, Dan lived with his wife and daughter in the little village of Conlig in Co Down and painted there with his friends, Gerard Dillon and George Campbell. He loved the countryside and he loved poetry and music. He also enjoyed life and the company of others but his romantic, sensitive nature was tinged with melancholy. He went to London in 1958, returned to Ireland twelve years later, and took up residence in Belfast. A great sadness permeated his later years. His marriage was over and he was alone. His paintings echoed his desolation of spirit. A tragic death from choking on food ended the life and work of this gentle, caring, thoughtful and loveable artist at the age of fifty-four.

Jessica was painted in 1960. The young girl looks out at us through dark, brooding eyes, in a simple pose, with quiet composure. It is a symphony of blues. A strong ray of light catches the side of her face, her long neck and the diaphanous dress. It is not so much a portrait of an individual as an image of youth, in the very personal style of Daniel O'Neill, and it is beautiful.

Beauty is something deep and hidden. It goes beyond good looks. True beauty mirrors the inner beauty of heart and soul. Glamour is fickle and transient, while beauty dwells at the heart of life, and can be discovered at every level. St. Peter admonishes us in one of his letters:

Your beauty should consist of your true inner self, the ageless beauty of a gentle and quiet spirit which is of the greatest value in God's sight. (1Peter 3:4)

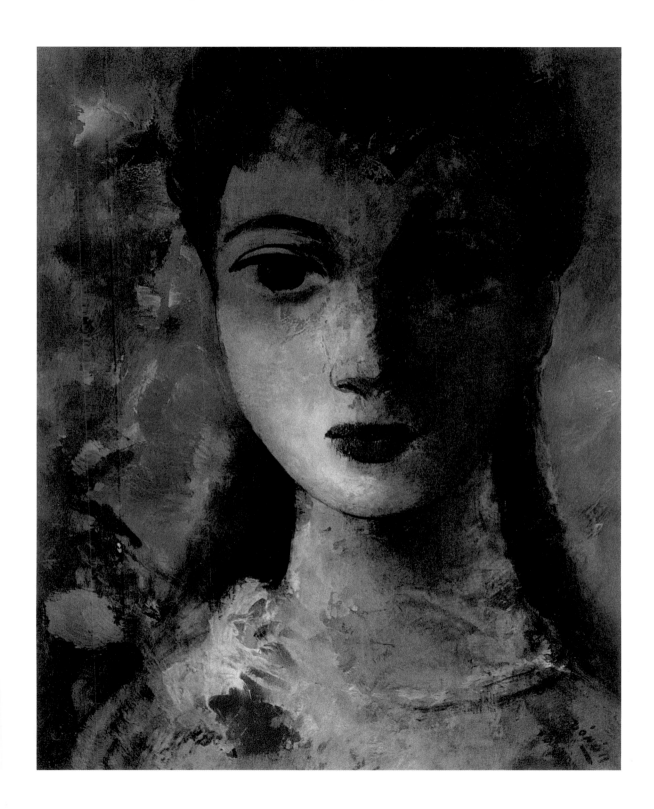

MARSH'S LIBRARY
by Walter Osborne RHA
(1859-1903)

There is a sense of serenity and humour in this painting of four senior citizens grouped around a table, with the cloth askew, deeply engrossed in their reading. It was painted by the sensitive brush of Walter Osborne, a charming, likable, fun-loving Dubliner, born in Rathmines in 1859. Art was part of his growing up, since his father was a well known painter of animals.

Young Walter went to Dr Benson's School near his home. It was hardly surprising that, on leaving school, he chose to become a painter. He enrolled as a student at the Royal Hibernian Academy School and for a time at the Metropolitan School of Art in Dublin. He was a brilliant student, winning many prizes even in his first year. In 1881 he won the Taylor Scholarship which enabled him to travel abroad. He decided to go Antwerp, not Paris, and registered at the Academie Royal des Beau-Arts. Here classes were free and living was cheap. He spent eighteen happy months in this fine city, learning his craft and perfecting his skills. In his spare time he and his fellow students roamed the villages and countryside, looking for suitable subjects. Osborne loved to work in the open air, struggling to convey the spirit of a place.

From Antwerp he went for a short time to Brittany. Then he set out for England, where he spent eight or nine years. He was strong and healthy, lived frugally, and "painted from morning till night". He returned to Dublin, to live there permanently, in the early 1890s, but made frequent visits to the Continent. In his old home he found himself responsible for his ageing parents and a young niece, whose mother had died in childbirth. It may have been this difficult situation that made him decide to turn almost exclusively to portraiture, quite possibly as a means of augmenting his limited income. He sought out clients and commissions, and became the leading portrait painter in Ireland. What a tragic loss it was when pneumonia claimed his life at the age of forty-three.

In *Marsh's Library* the painter combines portraiture with genre. Here are real people who, no doubt, often dropped in to the library, to read or research. The background of bookcases is suggested by a few strokes of the brush. Sufficient light comes through the window on the left to illumine a face, a hand, a book. The flawless composition is painted with a characteristically limited palette.

Life is a gift. There is only so much time given to each of us. As we grow older it is important to keep our minds alert by holding on to or developing an interest in something and our bodies supple by some activity. It is never too late to learn. Above all, it is important to seek the truth by reading and by prayer. What is truth? *"I am the way, the truth and the life"*, said Jesus, *"No one can come to the Father except through me"* (Jn 14:6).

Oil on canvas 38.1 x 30.5cm
Collection: Dublin City Gallery The Hugh Lane

MARE AND FOAL
by William Osborne RHA
(1859-1903)

It happens sometimes that a pupil outshines the master, or a son outshines the father. This was the case in the Osborne family. While William was a very fine artist, his son Walter outshone him, and became a greater and more successful artist. On the other hand the majority of William's paintings are in a special category and in that category he attained an excellence excelled by few anywhere.

He was born in Rathmines, a suburb of Dublin city in 1823. At an early age he was left an orphan and brought up by an uncle. The decision to send him to school in Leeds in England was not a good one. Young William never fitted in and was very unhappy there. When he expressed a wish to become a painter his uncle would not hear of it. Instead he was put to work in the office of a Dublin merchant, where he found the work tedious. He consoled himself by attending evening art classes. Eventually his uncle relented, withdrew his opposition, and a happy William pursued his artistic studies at the Academy Schools. His first ambition was to become a portrait painter but for whatever reason he switched to the painting of animals, becoming the foremost painter of his day in this genre and established a market for animal portraits. He loved all animals, but especially horses and dogs. He studied their habits, the way each animal moved or lay at rest. He observed their colouring, the texture of their coats, the restless vitality of some, the quiet disposition of others. Commissions poured in. In 1854 the RHA recognised him by making him an Associate member and elected him to full membership in 1868.

This painting is one of many William painted on the theme of mare and foal. The beautiful animals, standing in characteristic pose outside the stable door, fill the picture frame. Their magnificent rich brown silken coats are realised with smooth strokes of the artist's brush, but it is in the painting of the eyes that we are made aware of the sensitivity, intelligence and vitality of these thoroughbreds. We are also made aware of the bond between mare and her offspring by the way they are positioned. The rest of the painting forms a background, loosely painted in a scheme of warm, subtle colour harmony. It speaks of serenity.

From the lowest to the highest in the animal world there is a strong bond between mother and offspring. It is a loving, caring bond without sentimentality. The mother bird will push the baby birds out of the nest as soon as it is time for them to fly. Tiger cubs will learn the skills of hunting from their mother and then will have to fend for themselves. In the human species the love bond is strongest of all.

A mother will starve herself to feed her children; she will fight to protect them. Such love is but a pale reflection of the love of God for each of us, the invisible bond that binds us to Him.

"To both man and beast you give protection. O Lord, how precious is your love" (Ps 35)

Oil on canvas 50.5 x 69cm
National Gallery of Ireland Collection
Photos © National Gallery of Ireland

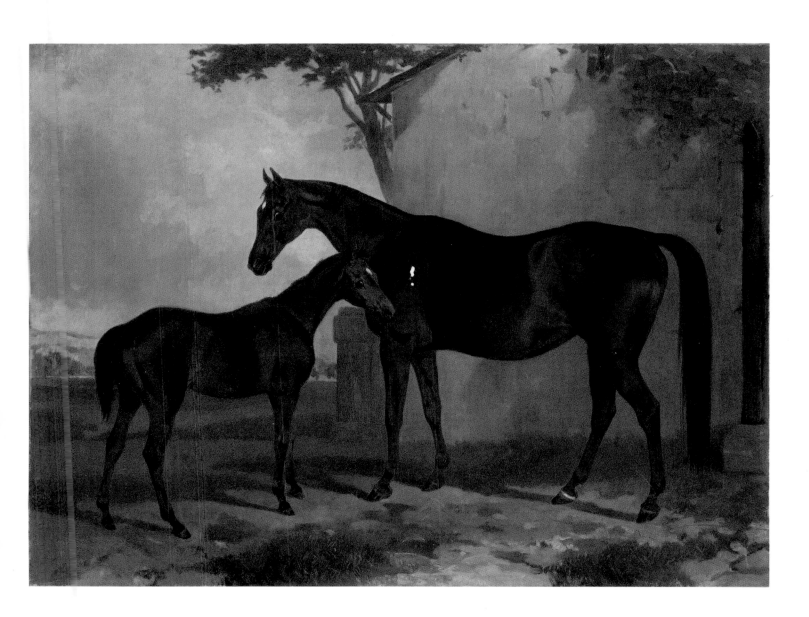

FISHWIVES GOSSIPING
by Sarah Purser RHA
(1848-1943)

Sarah Purser was born at Kingstown (now Dun Laoghaire), Co Dublin in 1848, into a family with artistic ancestry. At the age of 13 she spent two years in Switzerland where she learnt to speak French and to paint. She continued her art education at the Dublin Metropolitan School of Art. When the family financial situation deteriorated she borrowed money from her brothers and set out for Paris to the Academie Julian. Her idea was to study portraiture so that she could earn her living as a portrait painter. She worked hard, determined that her brothers would never regret their generous gesture. Her sojourn in Paris was short, just six months, though she was to visit there often in the future. Her homecoming may have been due to shortage of money, but more certainly to be with her mother, who lived at 19 Wellington Road, Ballsbridge, since the breakup of her marriage to Benjamin Purser.

The Pursers had been brewers for generations. Benjamin had to quit brewing and he opened a flour mill and bakery in Dungarvan, Co Waterford, in 1848, the year Sarah was born. Initially the business prospered and then collapsed. Benjamin Purser set sail for the USA, leaving behind his wife, who had become very discontented, and family. The separation of her parents affected Sarah deeply, but she pursued her chosen career with tenacity. Within seven years she had established herself as a professional painter, excelling in portraiture. Among her sitters were Jack B. Yeats, Maud Gonne, W.T. Cosgrave, and even royalty. "I went through the British aristocracy like measles", she said. Landscape also figured in her work, which had a vigour and freshness about it that appealed to the public and critics alike. She sold well, received many commissions and became a wealthy woman. Her personality was vivacious, witty and warm, but with a tendency to dominate. Well educated, talented and full of life she became the ideal hostess, entertaining artists, musicians and writers, at her home in Mespil House, a small Georgian mansion, which in collaboration with her brother, she had leased in 1909. Her Tuesday get-togethers became legendary. Among the many projects that she initiated and developed was the stained glass studio of An Túr Gloine. Up to her ninety-sixth year she was tireless in promoting art in Ireland. She died in Mespil House in 1943.

The seaside resort of Kinsale, in the south of Ireland, was one of Sarah's favourite places for a restful holiday, though, for her, restful did not mean idling the time away. She painted the sea, boats and especially the people in their natural environment. This painting of women gossiping was exhibited at the RHA in 1881. It shows three women sitting on the quayside, in animated discussion. The group is beautifully composed, colours are strong but neutral, and the figures are modelled with crisp, decisive strokes. The distinct personality of each woman is expressed by her features, pose and gestures.

Enjoying a good gossip can be harmless. On the other hand, *The tongue is powerful for its size and can take over a person (James 3:5)*. It has mighty destructive powers. The prophet says: *The lash of a whip makes a welt, but the lash of a tongue smashes bones (Sir 28:17)*

Oil on canvas 322 x 448cm
Private collection

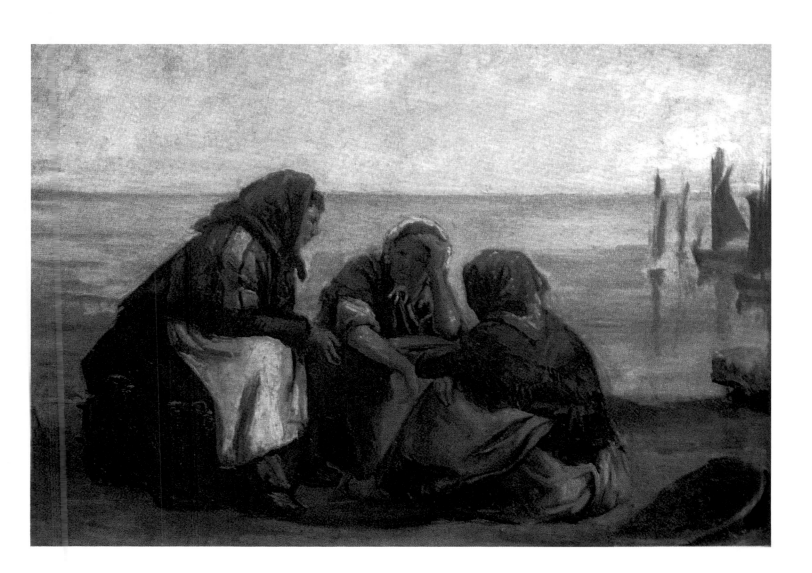

GOD PITCHED HIS TENT AMONG MEN
by Patrick Pye
(b. 1929)

"The beauty of the representation does not consist of its faithfulness to nature but in the beauty of another world which is somehow more real than the visible world, more charged with meaning." It is in these words that Patrick Pye gives us an insight into his approach to painting and it is in the light of these same words that we must seek the meaning.

The longer you look at this painting the more you become aware of the hidden depths that the artist is unveiling for us. "My art is intuitive, not intellectual" he says, so his intention is not to indoctrinate but to reveal. He uses themes that overflow from his own firm beliefs. He combines his great artistic talent with his Catholic certitude. In this canvas the sustaining power of the Trinity is graphically brought to life. The figure of the Father hovers over his creation, the power of the Holy Spirit is transmitted through the angelic figure who in turn points towards the Son, born of the Virgin Mary and living among us. He has pitched his tent on this earth. For the artist this is the focal point and he uses the bright yellow triangular shape to compel our attention. The inverted triangle above it links up again with the Father. The strong line supporting the star of Christmas joins earth to heaven. The wise men from the east are on their way. Swirling, flowing shapes in muted colours compliment the sharper triangular shapes in the overall composition.

Today you would find Patrick Pye in his studio in Piperstown though he was born in the English town of Winchester in 1929. His Irish mother, a highly intelligent Protestant lady, brought him to Dublin when he was a little boy. He was educated at St Columba's College, Rathfarnham. There he encountered Oisin Kelly, the sculptor, who taught art to the boys. Patrick remembers him as a kind, encouraging teacher. It was here, too, that he came across, in the library, a book on El Greco, the Spanish artist that, he said, held him spellbound and made him a painter. On finishing school he studied at the National College of Art in Dublin. Independence was important to him so he left home and took up residence in cheap lodgings in Mount Street, sharing his board with Patrick Swift, another artist.

He admits to many influences, apart from El Greco, in his pursuit of art. The poetry of T.S. Eliot had an enormous influence. In his travels in Europe he favoured the earlier painters, such as Giotto, rather than those of the High Renaissance. But however much he looked to others, he has carved out for himself a very special place in the world of art today. His work is mainly figurative, though he also paints still life and landscapes. However he is unique in his almost exclusive use of religious themes.

In this remarkable painting we are invited to ponder again on our belief in the Creator of Creation and in Christ, the Son of God who has come to live with us. He has pitched his tent among us, not for a day or a year but forever.

"I am with you always even to the end of time" (Matt 28:20)

Oil on copper
Collection Glenstal Abbey
© The Artist

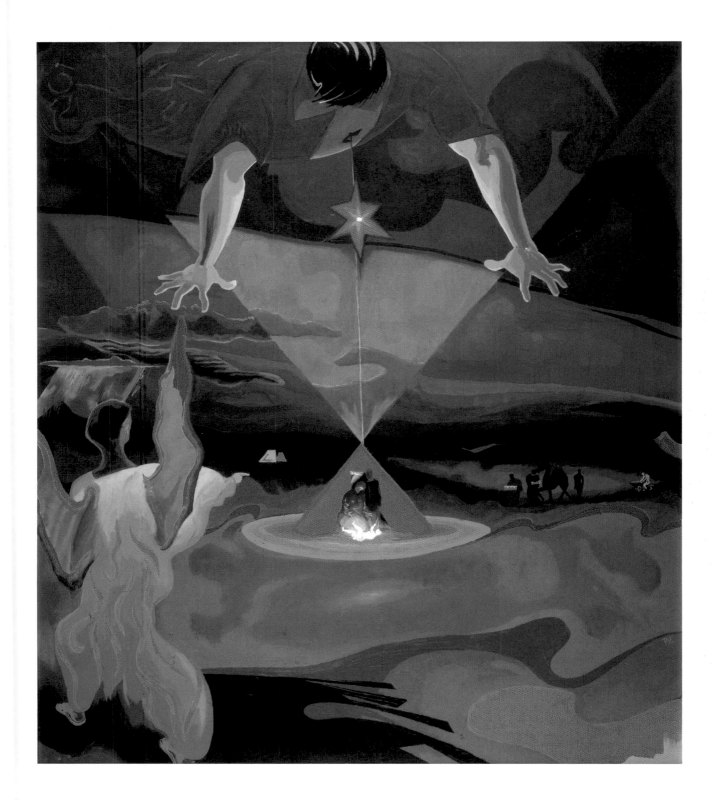

A ROSE
by Thomas Ryan PPRHA
(b. 1929)

A Limerick man through and through, Tom Ryan now lives in Ashborne, Co Meath. Art is his life. It is the only life he ever wanted, so when he left school he enrolled in the local School of Art in Limerick to begin his artistic studies. On coming to Dublin he continued his studies under Sean Keating and Maurice MacGonigal at the National College of Art. Influenced by his tutors, and from personal conviction, he has adhered to traditional academic values and style in his painting. Success for a painter is a slow process, but Tom Ryan got a break when a portrait of his was accepted by the RHA in 1957. He extended his range to include landscape, interiors, still life, historical and religious subjects. He has achieved a very successful career as an artist and is held in high esteem. His paintings hang in major public collections and private homes.

But it is with the Royal Hibernian Academy, usually referred to as the RHA, that his name will always be associated. The Academy's first premises, in Lower Abbey Street, were destroyed during the 1916 Rising. The annual exhibitions continued but had to be held in various venues. This unsatisfactory situation went on for a very long time, resulting in a decline in standard and influence. It was not until the doors of the new building in Ely Place were opened in 1985 that its fortunes were reversed and it recovered its prestige as a force in Irish Art. The turnabout was due in no small measure to Ryan's untiring dedication and hard work. He had become President in 1982. Three years later the first, very successful, exhibition was held in the unfinished building. The exhibits were hung on bare concrete walls. Success followed success. It can be truly said his presidency, from 1982 to 1992, marked a time of development and expansion for the RHA.

I have chosen this small painting of a rose from a number of major works of the artist because of its general appeal. The soft texture of the petals is conveyed by smooth, short brush strokes. The coins, acting as a balance to the composition, are hard edged and sharp, and offer a contrast to the delicate flower. Low keyed directional light picks out the edges of the petals and the rims of the coins, resulting in a beautiful meaningful painting.

The beauty and perfection of the rose speak of truth, purity and love, and while love is the most beautiful and sought after thing in life, it too has hard edges and painful thorns. To know the love of another is a life-giving experience. To give love is self-enriching. True love makes us free but it also binds. It is an echo of God's love for us, which is the only perfect love, totally selfless and self-giving.

God is in the garden,
Where beauty grows
For he who made the mountains
Bent to make a rose.

Sippor

Oil on canvas 18.5 x 12.5cm
Private collection

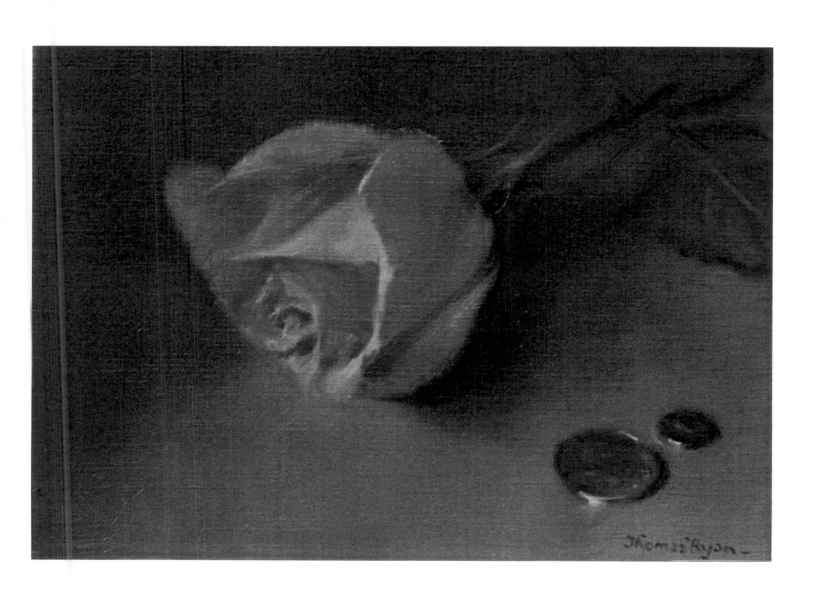

PORTRAIT OF THOMAS MOORE
by Sir Martin Archer Shee RA
(1769-1850)

Two Irishmen, both born in Dublin in the second half of the 18th century, and who both subsequently emigrated to London to become renowned as men of many talents. They befriended and supported one another, but Thomas Moore, the poet, musician and writer, is better known than the artist, writer and scholar, Martin Archer Shee.

The Shees were of ancient Irish ancestry, originally based in Mayo and later in Kilkenny. Little is known of Shee's immediate family, except that his father was a Dublin merchant, with headquarters at Usher's Quay. Martin was left an orphan at a very young age. He was given a home by an aunt, his mother's sister, who lived near Bray in Co Wicklow. Gifted artistically he was allowed to enrol in the Royal Dublin Society's Drawing and Painting School when he was only 12 years old. Here he won several medals and prizes, including a silver palette for drawing from life.

Still in his teens, he established himself as a portrait painter from a studio in Dame Street, Dublin. However on a friend's recommendation he went to London. He was only 19. At first, things were difficult, but support came from his compatriots, notably Edmund Burke, who introduced him to one of England's leading painters, Joshua Reynolds. Reynolds advised him to attend the Royal Academy Schools for further study. Acting on this advice he spent the next five years developing his technique and style, to become one of the best portrait painters among his peers, and received numerous outstanding commissions. Throughout these years he maintained a keen interest in cultural matters in Ireland. He married an Irish girl, Mary Power, from Youghal, Co Cork. He was elected a full member of the Royal Academy in 1800. When he was made President of this Academy, some thirty years later, following the death of Thomas Laurence, he wrote: "I feel gratified that the Academy has thought me not unworthy or incapable of following in his track." In that same year he received a knighthood.

This portrait of his friend Thomas Moore was painted in 1817, when Shee was at the height of his artistic achievements. According to the experts it is a copy of an earlier work, and not as well finished as the original. Nevertheless it is a vigorous and sensitive portrait. The poet-musician is seated at a cloth-covered table on which, significantly, are blank sheets of white paper. Moore seeks inspiration for those opening lines, as he stares into the middle distance, fingering his monocle. His dress is typical of the gentlemen of his day: a white cravat over a winged collar, tucked into a cream coloured waistcoat and a dark brown jacket. The head and hands are strongly modelled. The elaborate drape at the left gives a glow to the warm tonal colour scheme, very much in tune with the sitter's personality and his romantic musical melodies, known to all as *Moore's Melodies*.

No the heart that has truly loved
never forgets
But as truly loves on to the close.
As the sunflower turns on her God
when he sets
The same look which she turned
when he rose
(Moore's Melodies)

Oil on canvas 91 x 70cm
National Gallery of Ireland Collection
Photos © National Gallery of Ireland

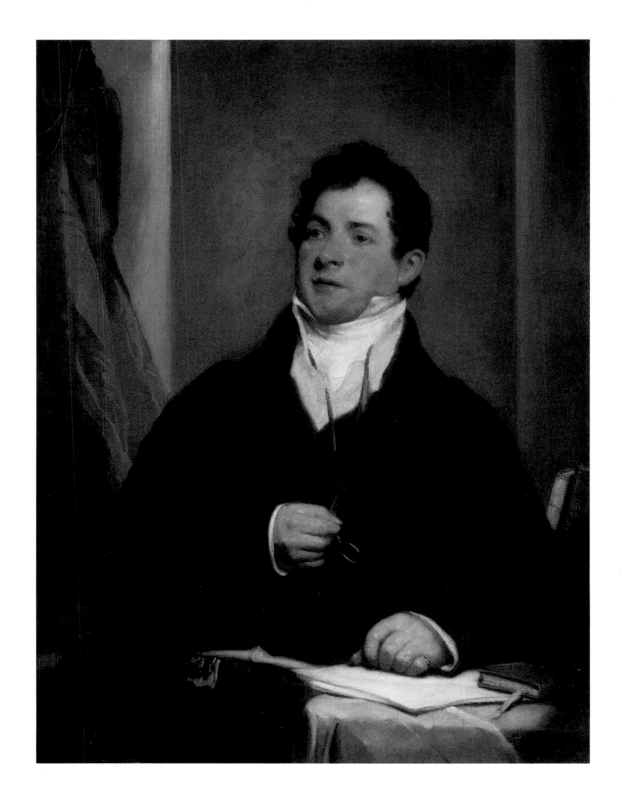

SAINT KEVIN AND THE BLACKBIRD

by Imogen Stuart RHA
(b. 1927)

The feel of wood, the smell of wood, the sound it makes when cut or gouged with a chisel are things that Imogen Stuart loves. She has an innate respect and feel for the material she uses, whether it is wood, stone, bronze, copper, steel, marble, limestone or cement.

She is German by birth, upbringing and artistic training; she is Irish by affinity and sympathy. She lived in Berlin throughout the upheaval of the Hitler years, but moved with her family to Bavaria at the end of World War II. From an early age she was interested in the visual arts, mainly through the influence of her father, Bruno Werner, who was a writer and an art critic. In the autumn of 1945 she became a private pupil of Otto Hitzberger, an outstanding Bavarian sculptor, who was her tutor and friend over five happy years. During this period a young Irish sculptor student, Ian Stuart, came to live with the Werner family to complete his studies, also under Hitzberger.

The young couple fell in love, married in 1951 and came to live in Ireland. It is here that Imogen has made her home. While she has had her share of happiness, she has also experienced suffering. The separation from her husband was a time of great grief and the death of her second daughter in a car crash nearly broke her heart. But Imogen is a strong, positive person, deeply spiritual, and this helped her to cope with her grief.

Inheriting a rich German artistic legacy, she has absorbed in a remarkable way the culture of her adopted country. In an interview with Brian Fallon she said: "I greatly admire the early Irish art: the illuminated manuscripts, the carved Celtic heads, the metal work, the beautiful ruins." This is evident in her own work. By choice she has become a carver rather than a modeller. The sculpture of St Kevin and the Blackbird is carved from pitch pine. Notice how the artist, empathising with her material, carves with the grain of the wood and not against it. She simplifies the head, the hand and the bird. She tells the story, using symbolism rather than realism, inviting us to ponder the meaning of the message behind the legend.

St Kevin founded a great monastery in the lower valley in Glendalough, Co Wicklow, where the two rivers meet. He loved solitude and, whenever he could, he escaped to the cave-like dwelling in the side of the hill overlooking the upper lake, to spend some time with the birds and the beasts, and to commune with God in prayer. The story goes that one day, as he prayed with outstretched arms, a blackbird alighted on his hand, and there laid her eggs. For fear of disturbing the bird Kevin kept his arm in the same position until the eggs were hatched! It is the story of love, perseverance and self-forgetfulness of a great saint, told in wood by a great artist, represented by a face deep in contemplation, a hand held steady and a contented blackbird. It is simple and beautiful.

"… He prays,
A prayer his body makes entirely
For he has forgotten self,
forgotten bird
And on the river bank forgotten
the river's name."
Seamus Heaney

Pine wood 61.5 x 39 x 28cm
© the artist

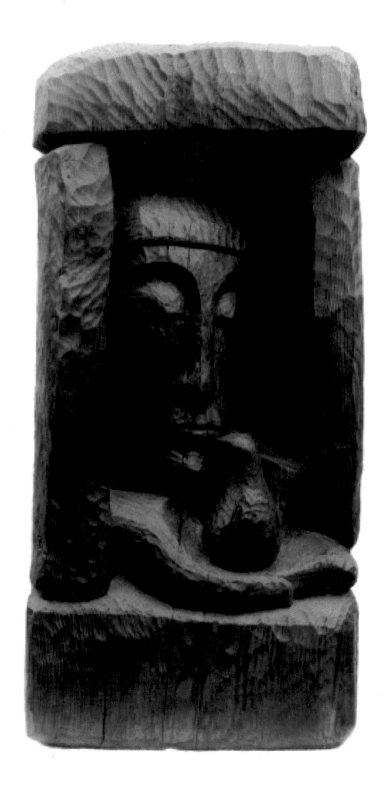

SAMOAN SCENE
by Mary Swanzy HRHA
(1882-1978)

This remarkable painting is the work of Dublin born Mary Swanzy, who was the daughter of a leading ophthalmic surgeon. Her painting career stretched from the beginning of the 20th century until 1978. She was still painting in her nineties. Her study of art started at May Manning's studio in Dublin and continued at the Dublin Metropolitan School of Art and the Royal Hibernian Academy. She won the Taylor Art Reward in 1902 and in 1905. Encouraged by her tutors to go abroad, she made the first of many visits to Paris in 1905, at the age of twenty-three, to work under Delacluse, who had a studio for young ladies. In subsequent years she came under the influence of other distinguished painters. She must have thrilled to the revolutionary movements succeeding one another in Paris at that time. Cezanne and the Impressionists were still popular, Van Gogh, Gauguin and Matisse were painting with bold vivid colours, Picasso and Braque were developing analytical cubism. Traces of all these movements can be detected in Swanzy's paintings at one time or another. She never concentrated on any one style. She was above all an experimenter. Her first solo exhibition was in her native city, and she exhibited frequently at the RHA.

In the early 1920s she became involved in the vigorous art movement in the city of Dublin and was one of the founder members of the Society of Dublin Painters, dominated by lively, enthusiastic, talented and sometimes powerful women painters. They helped to break the mindset of academic painting and encouraged new experimental ideas. Mary Swanzy was quite a formidable personality.

On the death of her parents she took to the road again, travelling extensively, including in her itinerary, California, Honolulu, and Samoa. The exotic surroundings she encountered and the people who inhabited them were an inspiration for numerous colourful canvases, a far cry from the little pictures of "pussy wussies and doggy woggies" expected of lady painters in Mary's day, as she said herself.

In this very large painting the artist depicts for us a Samoan paradise. The wide, luscious leaves on the left reach out to meet the contrasting, spiky plants in the right foreground, forming an archway that frames the group of bathers in full sunshine at the centre of the composition. The young Samoan girl, with her black hair and brown back, sitting in shadow, merges into the exotic growth around her. A tapestry of interlocking leaves, in tonal variations of warm and cool greens, forms a background. Here and there are parrots in complimentary red plumage. It is a wild fairyland of colours and textures.

Compare this scene with the soft, muted colours of an Irish landscape, the cold, forbidding snowscapes of the arctic regions, the majesty of mountainous places, and one can only marvel at the diversity in our world. The mystery of creation confronts us everywhere. We can deny that the world exists at all or submit to the fact of creation by which alone things could begin to be.

"In the beginning God created
heaven and earth"(Gen 1)

Oil on canvas 152 x 92cm
AIB Art Collection

WATER'S EDGE
by Donald Teskey RHA
(b. 1956)

The Mayo Coast in the West of Ireland is battered and bruised by the Atlantic Ocean. Great slabs of rock offer a continual resistance to wind, rain and sudden surges of water. It was here, standing at the edge of this rugged coastline that Donald Teskey found his inspiration for the formidable series of paintings under the title of *Tidal Narratives*. He has gone through many phases in his artistic explorations – hard-edged abstraction, where colour and shape became paramount, and then a form of expressionism. At the time of painting this large, powerful composition, he was seeking to find a balance between representation and abstraction. He chose as his subject a section of the western seaboard where the sea meets the land, offering a spectacular daily confrontation of the elemental forces of nature. Here the artist is more interested in the dynamic intersection of lines, the arrangement of textured shapes that direct the eye to a focal point, and a subtle positioning of light and dark tones, than in the actual scene before him. Blue, blue-black, umber, orange-red, yellow ochre and white were the oil paints on his palette. These were applied thickly with a float and a number of trowels, knives and brushes. It was the culmination of months of looking, sketching and soaking in the sights and sounds of the place.

The Teskey family, of Palatine extraction, came to Ireland from Germany at the beginning of the 18th century. They brought with them knowledge of the land and were skilled farmers. Donald was born in Rathkeale, Co Limerick, in 1956. As a child he loved to draw, and was encouraged by his parents. Later, when he attended the Limerick School of Art, he became passionate about drawing. In the Art School he found a great sense of energy and optimism and an excellent spirit among staff and students. As a preliminary to a large painting, he often makes small sketches in acrylic and positions these in his studio for study. When the time is ready he can paint with the spontaneity which he feels is vital to his work. By 1980 he was in Dublin and is currently working there. He was elected a member of the RHA in 2003 and is also a member of Aosdána.

To stand alone at the water's edge, to feel the flung spray in one's face and the knife-edge of the wind, to listen to the cacophony of the sounds of the sea is a wonderful experience. It is also a dangerous place to be. One false step could be fatal.

In life's journey it takes courage to walk to the edge, to risk the isolation, the fear of falling, of failing. But every great enterprise presupposes an element of risk. It is better to have tried and failed than to have done nothing. To trust in God and in his love for us, is to live at the edge. To stand firm when waves of unbelief threaten to overwhelm us, and the cold of doubt numbs us, is nothing less than heroic.

God is our shelter and strength,
so we will not be afraid,
Even if the earth is shaken,
Even if the waters roar and rage.
The Lord Almighty is with us
The God of Jacob is our
stronghold (Ps 46).

Oil on canvas 214 x 244cm
Image courtesy the artist & RubiconGallery

MADONNA
by Benedict Tutty OSB
(1924-96)

This little bronze Madonna comes from the hands of Br Benedict Tutty, monk and artist. He was from Hollywood, Co Wicklow, born there in 1924, of a large family of eleven children, and was christened John. After his schooling he trained as a butcher but God was calling him to walk a different path. He responded by entering the Benedictine Abbey of Glenstal in Co Limerick at the age of twenty-five, taking the name Benedict in religion.

His artistic talent was soon recognised, and he was sent to study metalwork at the Benedictine Abbey of Maredsous in Belgium, where there was a long tradition of craftsmanship. It was also from Maredsous that the monks had come to Glenstal some seventy years earlier. After three years Benedict returned to set up his own studio-workshop in Glenstal. He also taught for many years in the Limerick School of Art. Church commissions subsequently brought him to Germany and later to Paris.

At a Liturgical Conference in Glenstal, in 1962, he met the architect Richard Hurley and worked closely with him on a score of liturgical projects in Ireland and in England. He designed Stations of the Cross, Tabernacles, a series of doves and countless small works of art, both religious and secular in theme. It has been said of him that his work is *"Imaginatively compelling in concept and design"*. His materials of clay, metal or wood dictated to him how the part should serve the whole, never forcing his material to fit the idea, but letting it dictate the ultimate design. This reverence for the material is the sign of a true artist. At times, the spirit of the piece is conveyed by a gesture or by the posture of the figure. A successful retrospective of his work was held in Glenstal in 2010, fourteen years after his death in 1996.

Benedict constantly sought new ways of working, of giving form to his deepening spiritual life of prayer and contemplation. He combined the demanding life of a monk with the almost equally demanding life of an artist. We get an insight into this dual and often conflicting lifestyle in his sculpture. His own prayerfulness is echoed in the contemplative expression of the mother in the bronze Madonna, as she ponders the mystery of how she was chosen to be the mother of the Son of God. In that lovely face there is wonder and love, as she presents her little son to us. With a minimum of detail the artist conveys the intimacy of the mother and child. The mother's hands suggest both an enveloping love and a kind of awe. He is destined to be the Saviour of the world. There is a foretaste of the future in the serious face of the child and his extended arms. The cross overshadows the crib.

"O Mary of graces and Mother of Christ,
O may you direct me and guide me aright"

Bronze repousse 34 x 15 x 7cm
Limerick City Gallery of Art

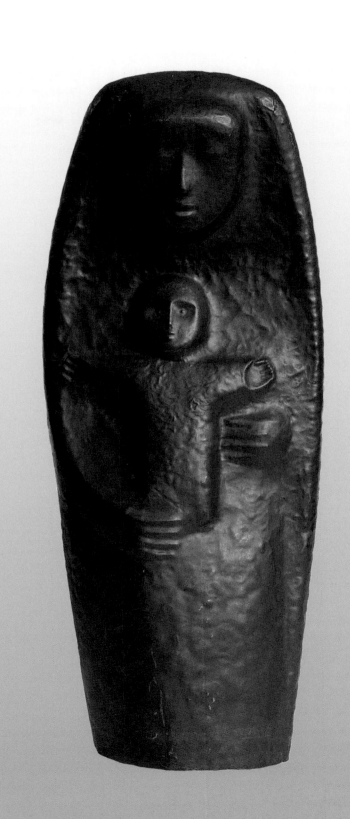

WEST OF IRELAND HARBOUR
by Barbara Warren RHA
(b. 1925)

When one looks at a Barbara Warren painting one is struck by its stillness and quiet quality. Her strength as a painter lies in the balance and serenity that pervades her canvases, in their soft tonal harmonies and always superb composition. Their sensitivity verges on the spiritual.

She was born in Dublin in 1925. On the completion of her education in Alexandra College, where she got a good foundation in art, instead of pursuing her artistic studies, she went to Belfast to join the WAAF. It was 1943 and she was just eighteen years of age. But World War II was at its height, so she spent the next two years working long hours at a UK training base for fighter-pilots. After the war she returned to Dublin and attended the National College of Art. For further study she went to the Regent Street Polytechnic in London. A short time later she travelled to Paris, gravitating towards the studio of André Lhote, where so many of her compatriots had studied before her. On her return to Dublin she spent much of her time in teaching. She taught private pupils, she taught at secondary school level, and she taught for ten years in the National College of Art and Design from 1973 to 1984. But she always found time to paint.

She paints still lifes, portraits, townscapes and landscapes, these latter more often than not in the west of Ireland. She has had many solo exhibitions. She submitted work to the Irish Exhibition of Living Art when it was in its heyday and to the RHA. She was made a full member of the Academy in 1984 and a member of Aosdána in 1990.

In this very pleasing painting of a harbour, somewhere in Connemara, the whitewashed cottages stand firmly at the edge of the ocean, a single boat rests in the calm waters of the tiny harbour; the solitary donkey slowly munches the green grass. Nothing moves, not a ripple on the water, not a movement in the grass, not a puff of smoke, not a bird in the sky. It is a picture of stillness, of balanced shapes, limited palette and narrow tonal range. It is neither pure representation nor abstraction but encompasses a bit of both. It somehow conveys to me a sense of aloneness.

To be alone or to be lonely are two very different things. A person can be lonely in a crowd, unable to fit in or connect. This can be a harrowing experience. But to *choose* to be alone often heals a troubled mind. It can also lead to an awareness of God, and is conducive to prayer. It is prayer that has the power to transform our lives. St Paul urges us never to cease to pray.

Oil on canvas 51 x 61cm
© The Artist

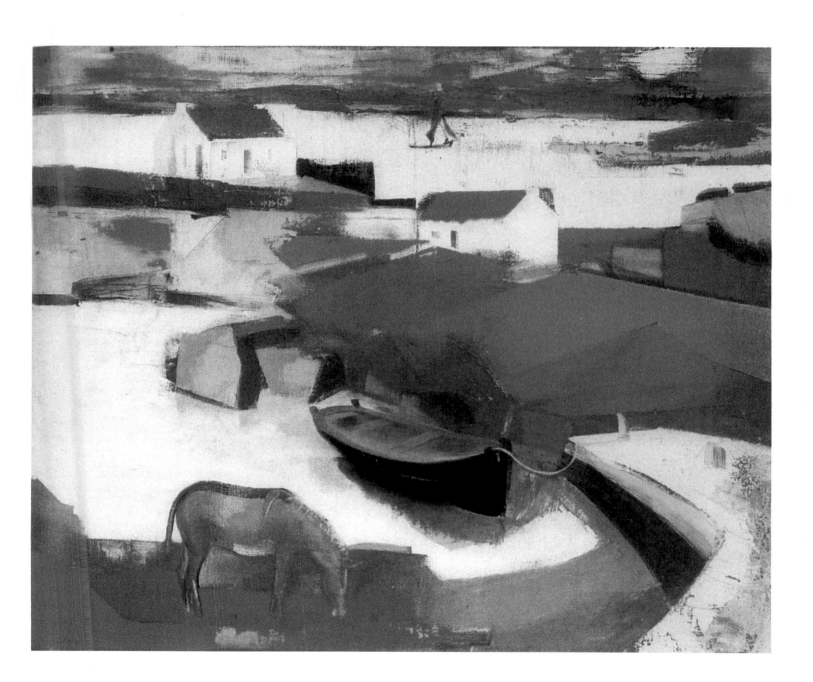

SILVER LIGHT, CLIFFS OF MOHER, CO CLARE
by Maurice C. Wilks RUA ARHA
(1910-1984)

Northern Ireland produced many notable painters during the 1930s and 1940s. One distinctive group excelled in landscape painting. While remaining distinctive in style they often used similar subject matter, were alike in the exactitude of their observation, and in the way they handled paint. Our present artist, Maurice Wilks, was one of these. Other familiar names were Humbert Craig, Frank McKelvey, Frank Egginton, Norman McCaig and Charles McAuley.

Born in Belfast in 1911, the son of a linen designer, Wilks received his education at Malone Public Elementary School. In the evenings he attended classes in drawing and painting at the Belfast School of Art. The family was of modest means, but a Dunville scholarship enabled young Maurice to pursue his artistic training full time. He studied every aspect of art, and painted some fine portraits. After college when he went to live in Cushendun, landscape painting took precedence over other forms. He painted around the Belfast docks, in the glens of Antrim, in Donegal, Kerry, and Connemara. When he was only nineteen he exhibited for the first time at the Royal Hibernian Academy. He loved to paint, he never sought acclaim or renown and he gave and continues to give, by his paintings, great pleasure to a great many people. They are still sought by collectors. They evoke the moods of the Irish countryside, the mountains and valleys, boglands and meadows and the all pervasive ocean. He went out at dawn and at dusk equipped with his painting gear, to capture variations of light, muted overcast moments, or magical colour combinations, which resulted in his beautifully crafted, romantic, landscape paintings. In the late 1970s after an absence of nearly thirty years, he returned to the Dublin scene and set up a summer studio in Sutton, Co Dublin. He died in his home in Belfast in 1984.

This peaceful painting of the Cliffs of Moher one of the wonders of the Clare coast in the West of Ireland was commissioned in 1980 when the artist was there on a holiday with his wife. Wilks chose a day when the pearly-clouded sky cast streaks of light on the calm waters and bathed the receding cliffs in a hazy mist. He painted the nearest cliff in sharp focus, with bright colours and strong textured strokes, but he uses muted colours and diminished definition to suggest the cliffs as they move away into the distance. All is calm here, but this part of the west coast can be whipped into a frenzy of dark and treacherous angry waves. Nature's moods are many.

We are part of the natural world and our moods too can vary like the wind and the sea. Waves of anger, lust or envy can rise up suddenly and threaten to engulf us. Willpower alone is, sometimes, not sufficient to stop the sudden surge. We need God's help. It is good to feel that need. In my weakness you are strong, O Lord, in my troubles you are peace.

Your Spirit is at work when understanding puts an end to strife, when hatred is quenched by mercy and vengeance gives way to forgiveness
(Preface of the Mass).

Oil on canvas 45.6 x 61cm
The Gorry Gallery

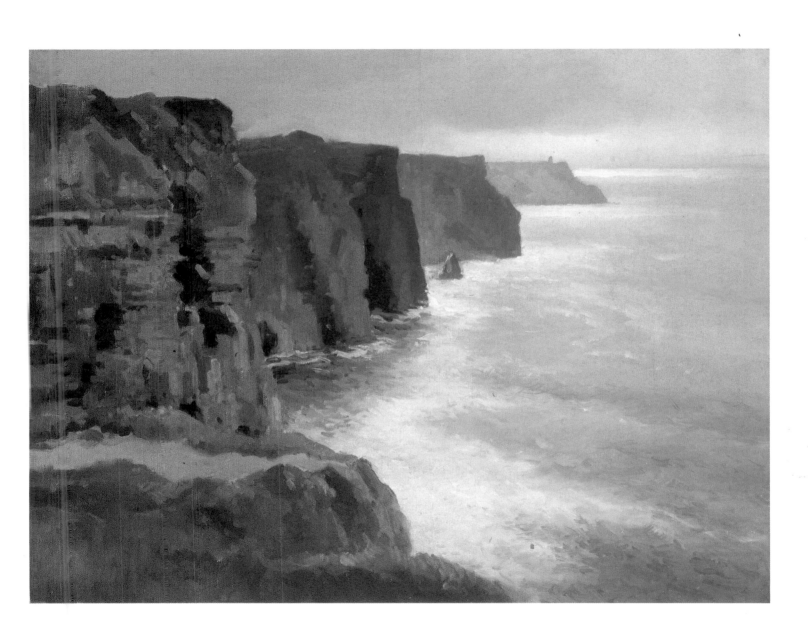

Acknowledgements

In putting this book together I have been helped by many people, and I owe them a debt of gratitude.

First of all I would like to thank Anne Duff Griffin for thinking up the idea of this unique series which has brought comments from people in many parts of the world.

My gratitude goes out to Ray Carroll MA who has read and in some cases reread the scripts, making perceptive and helpful suggestions and for his encouragement when difficulties arose.

The area of copyright permission is strewn with problems, so I am particularly grateful to the following for their help. To Catherine King for her advice and endless patience; to Eve Barrett who enabled me to contact the McGuinness family; to Carole Froude Durix for being so helpful and for allowing me to use the image on the cover; to Jim and Therese Gorry who did everything in their power to help; to Barbara Warren for her gracious permission; to Thomas Ryan, a great and courteous gentleman; to Richard Nisbet on behalf of his father Thomas; to Cecil Maguire for his willing permission; to Gretta O'Brien for being so welcoming; to Josephine Hayes and to Mr and Mrs Westerholt for allowing us to have the painting of Earnest Hayes photographed and to Pádraig Thornton for going to such lengths to photograph it; to Doreen Leonard for receiving me with kindness; to Bill Kelly of Kelly's Resort Hotel, Rosslare, for allowing me to use one of the paintings from his collection. To all the artists, private individuals and collectors who made their paintings available I would like to extend my deep gratitude.

I am also extremely grateful to the Art Galleries and to the people representing them: Michelle Ashmore (Ulster Museums); Louise Morgan and Marie McFeely (National Gallery of Ireland); Liz Forster (Dublin City Gallery The Hugh Lane); Siobhan O'Reilly (Limerick City Gallery of Art); Mandy (Oriel Gallery); Maureen Porteous (AIB); Edelle Hughes (Whytes); Josephine Kelliher (Rubicon Gallery); Anthony Costine (Waterford City Council); to my Dominican Sisters for their generous financial assistance.

It is the art of putting together the materials that constitutes the book. For doing this so beautifully I am indebted to the designer, Emer O Boyle and to the publisher, Sean O Boyle of The Columba Press.